Zen Doodle Inspiration

Earth, Air, Fire, and Water

Carolyn Scrace

First edition for North America, the Philippines, and
Puerto Rico published in 2015 by Barron's Educational
Series, Inc.

First published in Great Britain in 2015 by Book House,
an imprint of The Salariya Book Company Ltd.

© The Salariya Book Company Ltd MMXV
25 Marlborough Place, Brighton BN1 1UB

All inquiries should be addressed to:
Barron's Educational Series, Inc.
250 Wireless Boulevard
Hauppauge, New York 11788
www.barronseduc.com

ISBN: 978-1-4380-0718-2

Library of Congress Control No.: 2014956697

Printed in China
9 8 7 6 5 4 3 2 1

Zen Doodling Inspiration

Earth, Air, Fire, and Water

Carolyn Scrace

Contents

Zen Doodling
Meditation and Mindfulness

The repetitive, calming nature of drawing patterns not only results in a fabulous piece of art, but also has an inner effect—it creates a sense of focus and "coming together." Zen Doodling encourages mindfulness and can become part of a meditative practice that helps quiet the mind, which can lead to experiencing a deep sense of peace and calm.

Creative Confidence

The striking results will boost your artistic confidence, develop your skills, and release your imagination. The wonderful thing about Zen Doodling is that there is no right or wrong way to do it—happy accidents often produce some of the most exciting art.

This book introduces the use of shading to create 3D effects and explains basic color theory. It explores a variety of fun and simple techniques, from indenting to creating stencils and printmaking.

Experiment

Find out how to design patterns based on the natural world. Learn to experiment with different designs and compositions. Try using specific themes to create Zen Doodled art.

Inspiration

Earth, Air, Fire, and Water

Zen Doodling Inspiration takes the classical concept of the four elements—Earth, Air, Fire, and Water—as its starting point. It is my personal exploration of Zen Doodle patterns that can be found in the natural world. I want to show how inspiration can be found in the patterns of raindrops, ripples in puddles, windblown fields of corn, or a flickering candle flame.

Vibrant Patterns

As you learn to look at things differently, you will begin to see that the world around us is full of vibrant, exciting patterns, shapes, and colors. You will develop a new appreciation for, and be inspired by, the miraculous world we live in.

Mood Boards

This book, like my own journal, is packed with inspiring designs and ideas that can be used as the basis for your own patterns and compositions. Each section begins with a mood board, a collection of themed images designed to stimulate ideas and creativity.

Vincent van Gogh once said, "It is not the language of painters but the language of nature which one should listen to; the feeling for the things themselves, for reality, is more important than the feeling for pictures."

Pencil sharpener

Graphite pencils range from hard to soft.

Eraser

Compasses

Protractor

Tools and Materials

To start Zen Doodling, all you really need are some scraps of paper and a pencil. Although there are endless art materials that can be used, I tend to work with whatever I have on hand. The most important thing is to experiment—and use whatever tools and materials you find fun and exciting.

Use colored pencils for coloring over indented designs.

White wax crayon for doodling a resist pattern

Felt-tip pens come in a range of thicknesses.

Fineliner pens produce a flowing line. They work best when used over colored inks and watercolor paint.

Metallic and white gel pens are ideal for doodling onto colored paper or over dark areas of color.

Felt-tip pens

Fineliner pens

Metallic and white gel pens

Masking fluid to create white areas under a watercolor or ink wash

Polystyrene makes an ideal printing block.

Polystyrene sheet

Ruler

A ballpoint pen that has run dry is a useful tool to indent designs.

Scissors

I use my sketchbook to jot down ideas and try out designs.

Ballpoint pen that has run dry

I like to keep notes about the materials and methods I've used when experimenting with new techniques.

Types of Paper

Cartridge paper comes in a variety of thicknesses. Thicker paper is best for water-based paints.

Colored paper is great for trying out different effects and color schemes. Use it for printing different versions of the same image.

Sketchbook

Use a brayer roller to apply ink or paint to the surface of a printing block.

Paintbrushes come in a wide range of shapes and sizes.

Block-printing paint is an ideal medium for many printing techniques.

Brayer roller

Block-printing paint

Primary Colors

The three primary colors are red, yellow, and blue. They cannot be made by mixing any other colors. All other colors are derived from them.

Tertiary Colors

Red-orange, yellow-orange, yellow-green, blue-green, blue-purple, and red-purple are tertiary colors. They are made by mixing a primary and a secondary color.

Secondary Colors

Purple, orange, and green are secondary colors. They are made by mixing two primary colors (see above).

Color Theory

Color Temperatures

Reds, oranges, and yellows are warm colors associated with fire and earth. They reflect feelings of happiness, energy, passion, and enthusiasm.

Greens, blues, and purples are cool colors associated with air and water. They reflect tranquillity, calmness, and order.

RED

Red-purple

Red-orange

PURPLE

ORANGE

Blue-purple

Yellow-orange

BLUE

YELLOW

GREEN

Blue-green

Yellow-green

Complementary Colors

Red and green are complementary colors, as are orange and blue. They lie opposite each other on the color wheel (above). Placed side by side, they create vibrant, clashing color schemes.

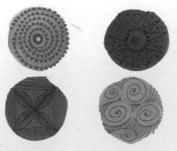

Analogous Colors

Analogous colors lie next to each other on the color wheel. Use them to produce harmonious color schemes.

≫ Light and Shade ≪

Adding shading to specific areas of a doodle can give the appearance of depth and can produce a sense of three dimensions. Shading can also be used to make parts of an image blend into the background.

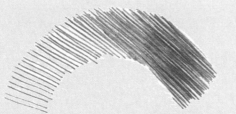

Hatching builds up tone using a series of thin parallel lines. Drawing the lines closer creates darker tones.

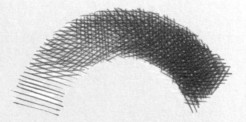

Cross-hatching is when a second set of parallel lines crisscrosses the first. Add more sets of lines to create darker tones.

Use scribbling for shading various textures. To create dark tones, simply make the scribbles denser.

Smudging is a useful technique for blending graphite pencil shading. Simply use the tip of your finger to smudge the pencil lines.

Before and After

The unshaded sphere, cube, and cylinder look flat and dull in comparison to the shaded versions below.

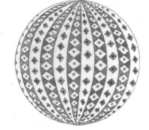

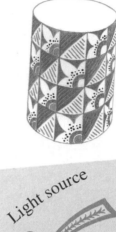

Before you start to add shading, decide the direction of the light source. Build up layers of tone gradually, leaving the lightest areas unshaded.

Light source

Artist's tip: To see if the shading is effective, try looking at your drawing through partially closed eyes!

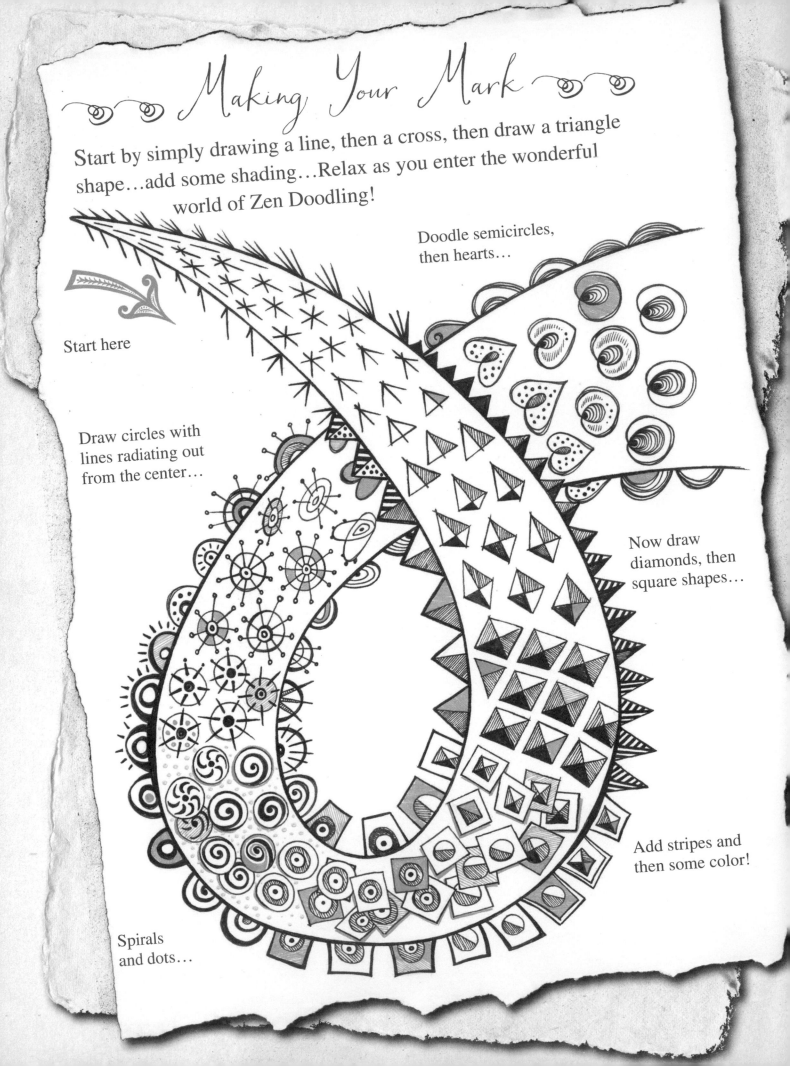

Making Your Mark

Start by simply drawing a line, then a cross, then draw a triangle shape…add some shading…Relax as you enter the wonderful world of Zen Doodling!

Doodle semicircles, then hearts…

Start here

Draw circles with lines radiating out from the center…

Now draw diamonds, then square shapes…

Add stripes and then some color!

Spirals and dots…

Experiment: Create an exciting background made from pieces of torn colored paper. Zen Doodle onto it using some of the patterns you have just created.

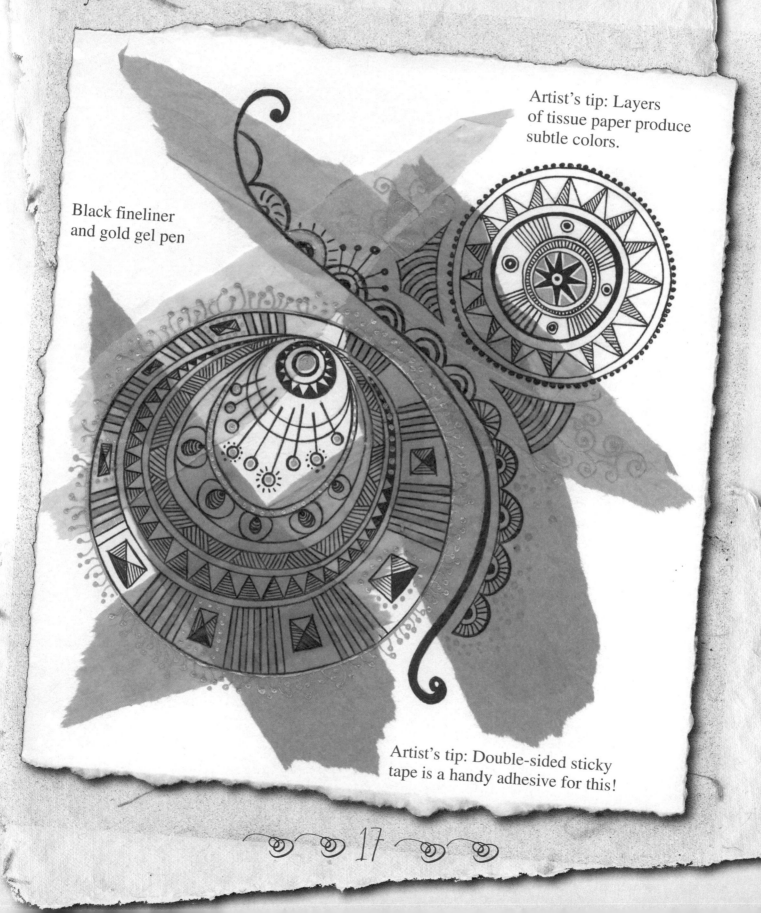

Artist's tip: Layers of tissue paper produce subtle colors.

Black fineliner and gold gel pen

Artist's tip: Double-sided sticky tape is a handy adhesive for this!

Earth

The earth is an incredibly diverse and stunningly beautiful habitat. It provides us with protection, food, and energy, and it is the life force for everything. Earth is the fixed element that accommodates the other three. Water flows around and over it, thereby shaping its contours. Air that flows around it is constantly remolding the shape of the earth's landscapes. Fire, on the other hand, lives within the earth, but could not exist without the earth's matter to feed it.

"Forget not that the earth delights to feel your bare feet
and the winds long to play with your hair."

Khalil Gibran

19

Earth-Inspired Mood Board

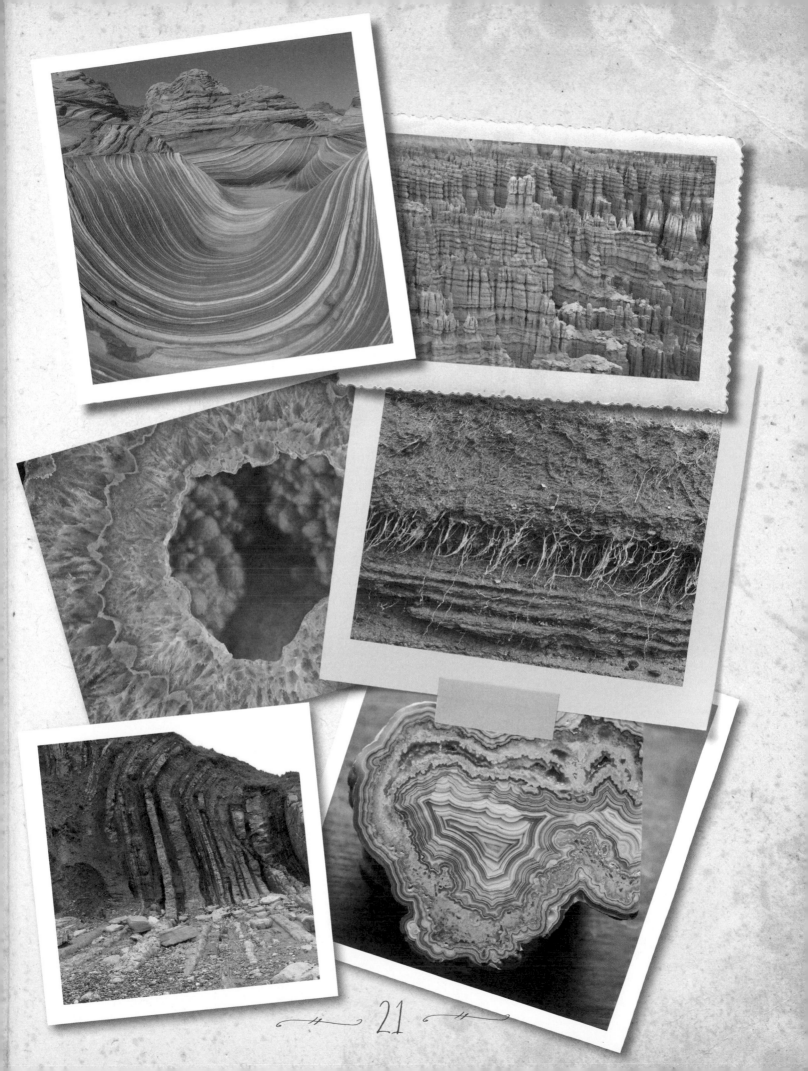

Pebbles on the Beach

The mesmerizing sound of waves rolling over pebbles always relaxes and comforts me. Delicately colored and beautifully shaped, each pebble is unique. Pebbles have a sense of serenity, peace, and harmony, perhaps because they each hold a part of the earth's geological past that links us with the evolutionary processes of our planet.

Color Swatches

Yellow ochre

Burnt umber

Burnt sienna

Prussian blue

Red-orange

Gray

Try sketching some pebble shapes. Using an old paintbrush and some watercolor resist, paint on stripes and dots. Once the resist is dry, use watercolors to paint in the pebble shapes.

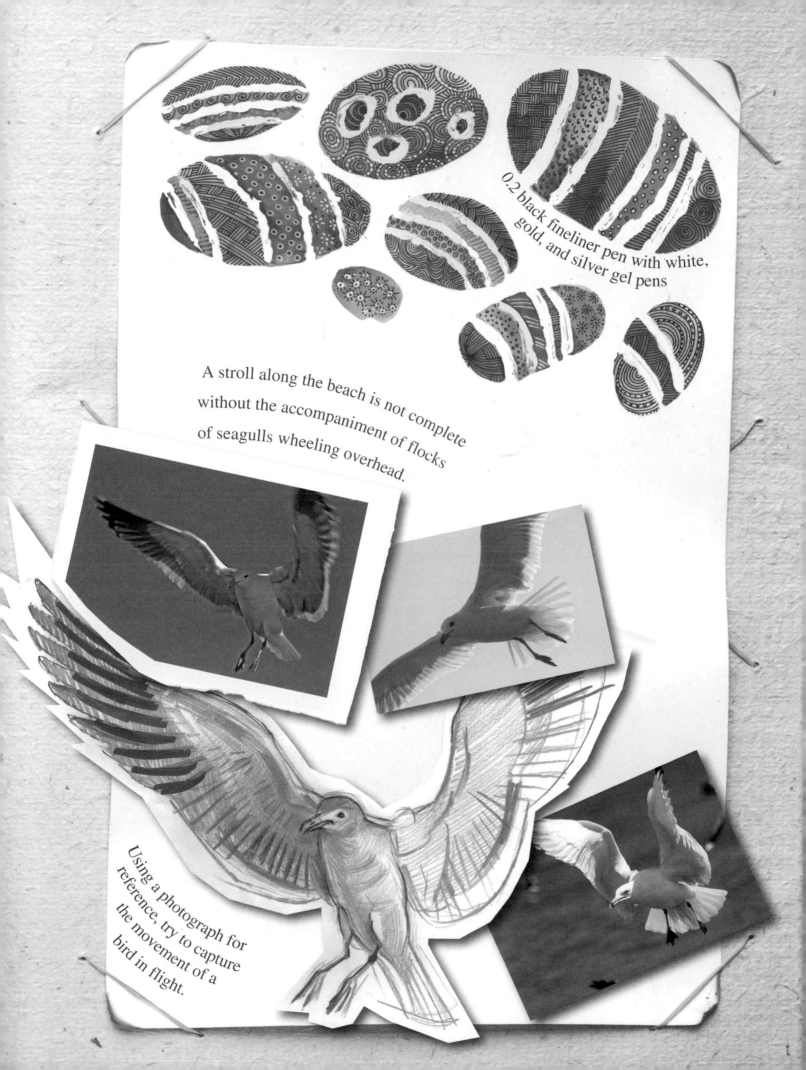

0.2 black fineliner pen with white, gold, and silver gel pens

A stroll along the beach is not complete without the accompaniment of flocks of seagulls wheeling overhead.

Using a photograph for reference, try to capture the movement of a bird in flight.

✍ Design Ideas ✍

Experimentation

Copy or trace several bird photographs to use for experimentation. I find it liberating to work on rough sketches rather than finished artwork, and it's great fun, too. Try out different designs, using feather patterns as a starting point.

Work in pencil, ballpoint pen, black and gray felt-tip pens—whatever you prefer. Don't worry if something doesn't work; that is the point of experimenting!

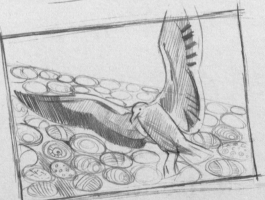

Different Compositions

Create rough thumbnail sketches of different compositions. Tilting the horizontal line of the beach results in a dynamic design—for added impact try cropping the bird's wingspan.

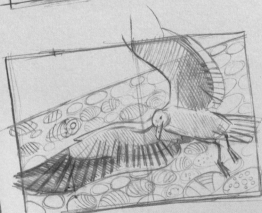

Potato Prints

My old kitchen knife was ideal for this task. Chop the potatoes in half to make printing blocks and then cut out grooves, spirals, and star-shaped patterns.

Different Shades

I used a paintbrush to apply paint to the potato blocks. I mixed a different shade of gold, copper, and gray gouache each time I made a print. I pressed down hard on the potato with the palm of my hand, and then lifted the potato off again.

I printed the potato blocks (middle) onto a sheet of gray-flecked paper. Brown wrapping paper (left) also makes a great alternative.

♡ Scaling up ♡

Scaling up is an easy method to enlarge an image. Lay a sheet of tracing paper over the picture you want to enlarge, then draw in a simple grid. Now draw a larger grid on another sheet of paper at the required size. Copy each square of the small grid onto the bigger grid to enlarge.

Simplify

Simplify the bird but retain its distinctive gull shape. Think of the patterns you want to Zen Doodle as you sketch the outlines of the wing feathers.

Scaled-up drawing of a seagull using pencil on tracing paper.

♡ 27 ♡

Doodling the Seagull

Trace your finished seagull design onto thick cartridge paper, then cut it out. Use double-sided tape to stick the gull shape onto the pebble-print background.

Feather Pattern One

Draw a simple pencil grid to help you Zen Doodle the pattern more easily. Break the design into simple steps using the guide (above). I used black fineliner pen for the main design and dark gray for the short, curved lines.

Feather Pattern Two

Draw a simple pencil grid, then gradually build up the pattern using black and pale gray fineliner pens.

Feather Pattern Three

Use the pencil grid as a guide to draw in the staggered row of scallop shapes (black and pale gray fineliner with gray felt-tip pen).

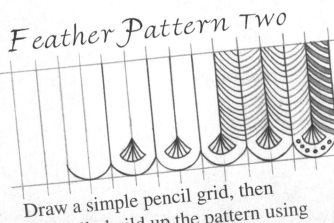

28

Feather Pattern Four

Use the pencil grid to help position the scalloped edge and the circles (black and pale gray fineliner pens).

I scanned the picture to my computer (right), then changed the color balance!

Seaside Memories

The sea has personality and ever-changing moods: calm and tranquil one moment, then wild and raging the next. Whenever I'm close to the sea, it fills me with a sense of perspective, scale, and permanence that washes away the insignificance of my own troubles.

Chest feather pattern in pale gray fineliner pen.

Zen Doodle the pebbles using fine felt-tip pens.

30

Shading

To make the gull stand out, add pencil shading to the wings, close to the body. Lightly shade the underside of the bird's chest and tail feathers, too.

♡ Crystal Maze ♡

Amethyst, a variety of quartz, is a semiprecious gemstone. For centuries, amethysts have been prized for their mystical healing powers. They are believed to be associated with love and are thought to promote feelings of calmness, serenity, and contentment.

Vanishing point

3D Composition

This dramatic, three-dimensional composition starts with a vanishing point. Each line of the elongated crystal shapes radiates upward from a single point.

Monochrome Color Scheme

✳ Plus white, gray, and black

A monochrome color scheme uses different shades or tints of the same hue.

Thumbnail Sketch

Make a thumbnail sketch of the design. To enhance the three-dimensional effect, experiment by blocking in areas of tone. Try adding some simple Zen Doodling patterns using purple fineliners and felt-tip pens.

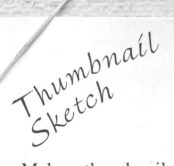

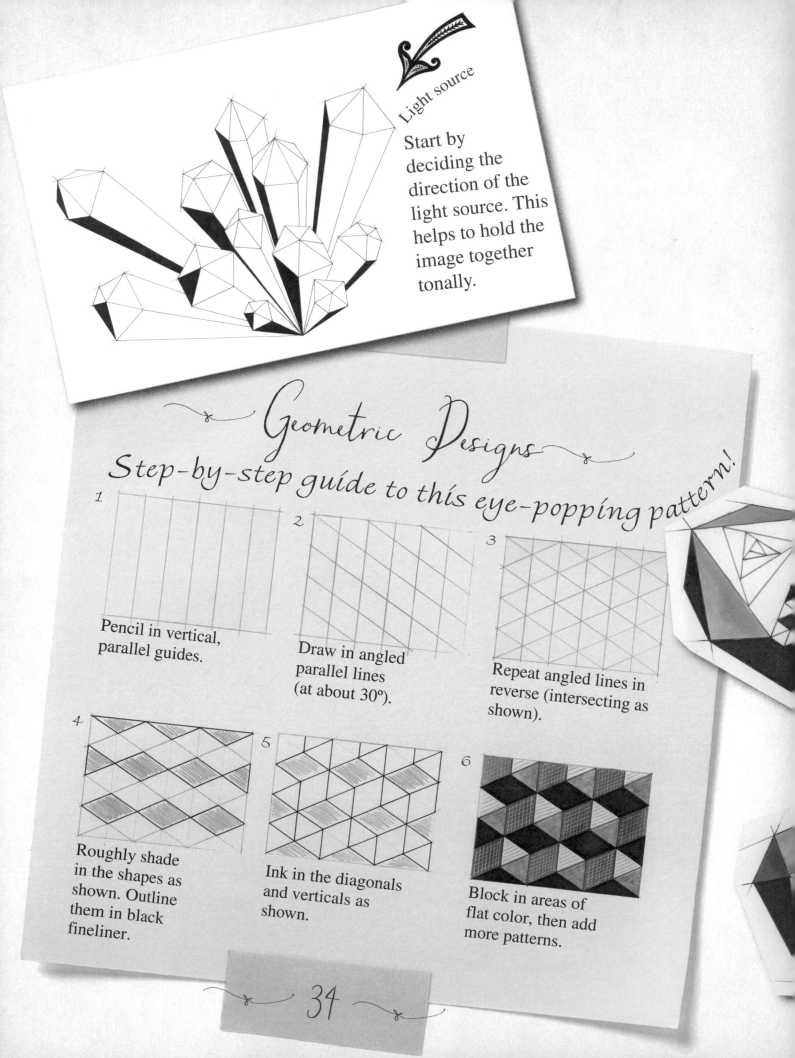

Light source

Start by deciding the direction of the light source. This helps to hold the image together tonally.

Geometric Designs

Step-by-step guide to this eye-popping pattern!

1 Pencil in vertical, parallel guides.

2 Draw in angled parallel lines (at about 30°).

3 Repeat angled lines in reverse (intersecting as shown).

4 Roughly shade in the shapes as shown. Outline them in black fineliner.

5 Ink in the diagonals and verticals as shown.

6 Block in areas of flat color, then add more patterns.

Patterns Deconstructed...

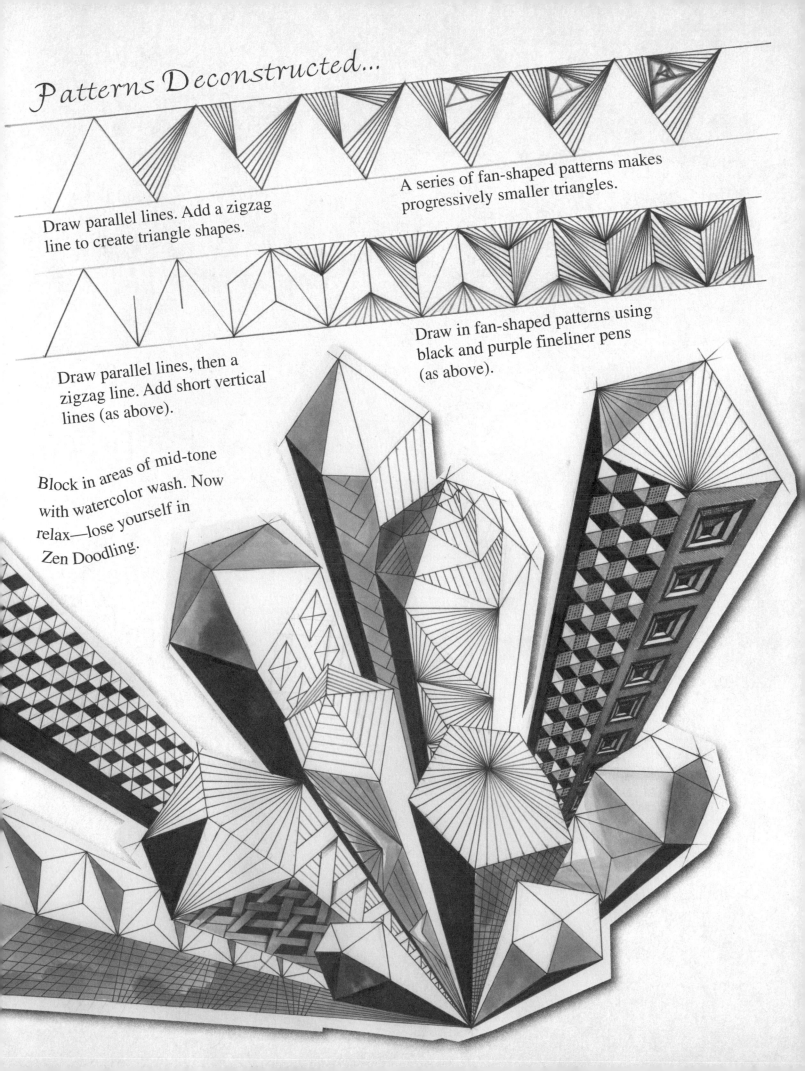

Draw parallel lines. Add a zigzag line to create triangle shapes.

A series of fan-shaped patterns makes progressively smaller triangles.

Draw parallel lines, then a zigzag line. Add short vertical lines (as above).

Draw in fan-shaped patterns using black and purple fineliner pens (as above).

Block in areas of mid-tone with watercolor wash. Now relax—lose yourself in Zen Doodling.

♥ Adding Shade ♥

Before...

Using a limited palette of colors in shades of purple, gray, and black, start adding Zen Doodles to the geometric design. These patterns reflect the geometric structure of the crystal. Add pattern to one section at a time, always keeping in mind the direction of your light source.

Light source

Artist's tip: Try squinting at the image through half-closed eyes to see if the tones are dark enough.

Watercolor Background

Watercolor washes can produce wonderful, exciting effects.

Watercolor Wash

Method

Use a sheet of thick cartridge or watercolor paper (larger than your design). Wet the entire surface with water using a clean sponge or large paintbrush. Blot off any puddles, then splash or drizzle watercolor paint onto the damp surface. Let the paint bleed, or tilt the paper to make the color run. Leave until completely dry.

Carefully cut out the amethyst design, then secure it in place using double-sided tape.

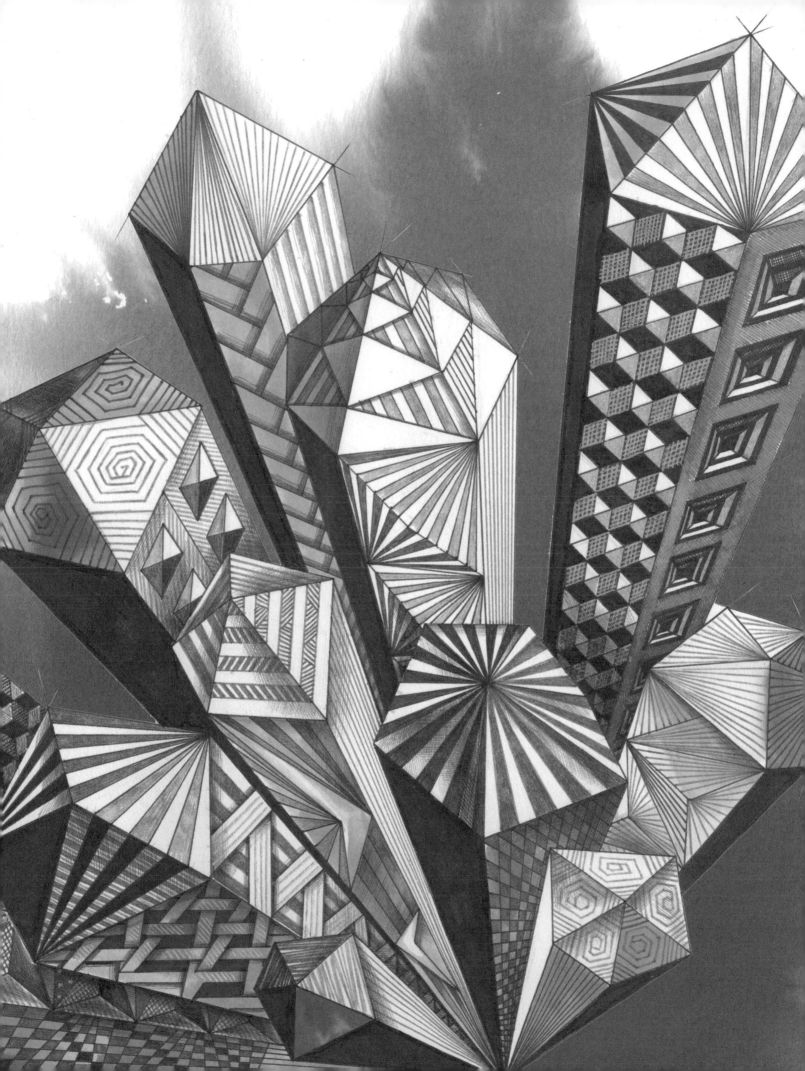

Landscapes

I find landscapes to be one of the richest sources of Zen Doodle inspiration. Landscapes are packed with visual delights: trees and hedges, fields of crops, furrowed ground, and rolling hills. Try seeing each view as a series of simple shapes, then find the patterns within and start doodling.

Rough Sketch

Pencil, black gel, and felt-tip pens.

I've used dark, scalloped shapes for the hedging that defines the checkerboard pattern of the fields. I've also tried to capture the essence of the wildflower meadow in the foreground by using a repeating pattern.

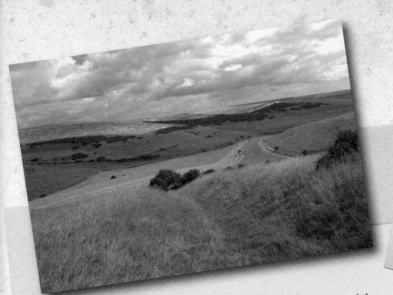

Pick and Choose

The joy of Zen Doodling landscapes is that you don't have to recreate reality. Combine shapes and patterns chosen from different views, as shown.

Rough Landscape Doodle

Startling Effect

Create the unexpected by using black and white Zen Doodles throughout the sketch, then add vivid reds and oranges for the poppies.

Thumbnail Sketch

Start with thumbnail sketches
of your composition.

~ Rolling Hills ~

I've based this composition on the
previous sketches. I particularly
wanted to incorporate the poppy
field, and tried using poppies as the
theme for a striking border design.

Movement and Depth

To capture the feeling of movement,
I've exaggerated the curves of the
rolling hills. Use perspective when
drawing in the checkered pattern of
the fields—this will add depth to
your composition.

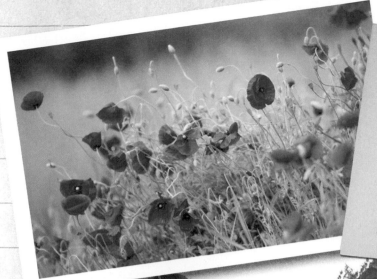

Bold Graphic Design

Alternatively, transform a rather mundane Zen Doodle landscape into a bold graphic design by adding a row of enormous poppies in the foreground (below).

Use a piece of sponge to dab on red paint for the giant poppy heads!

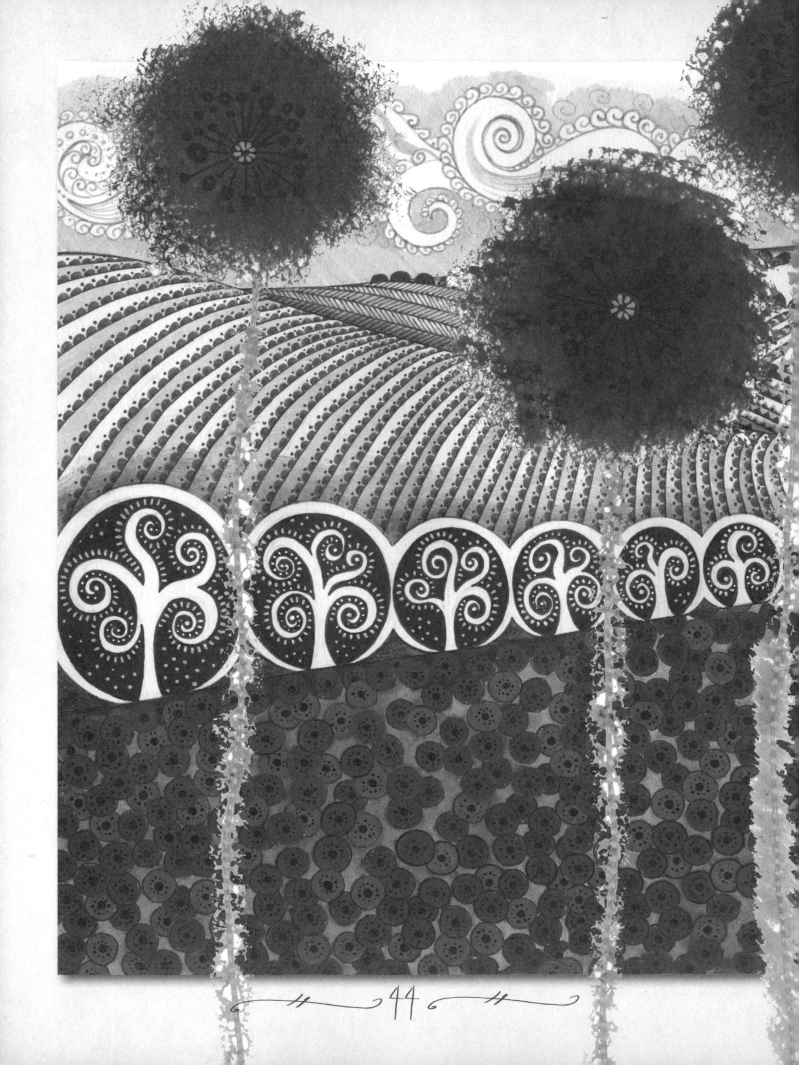

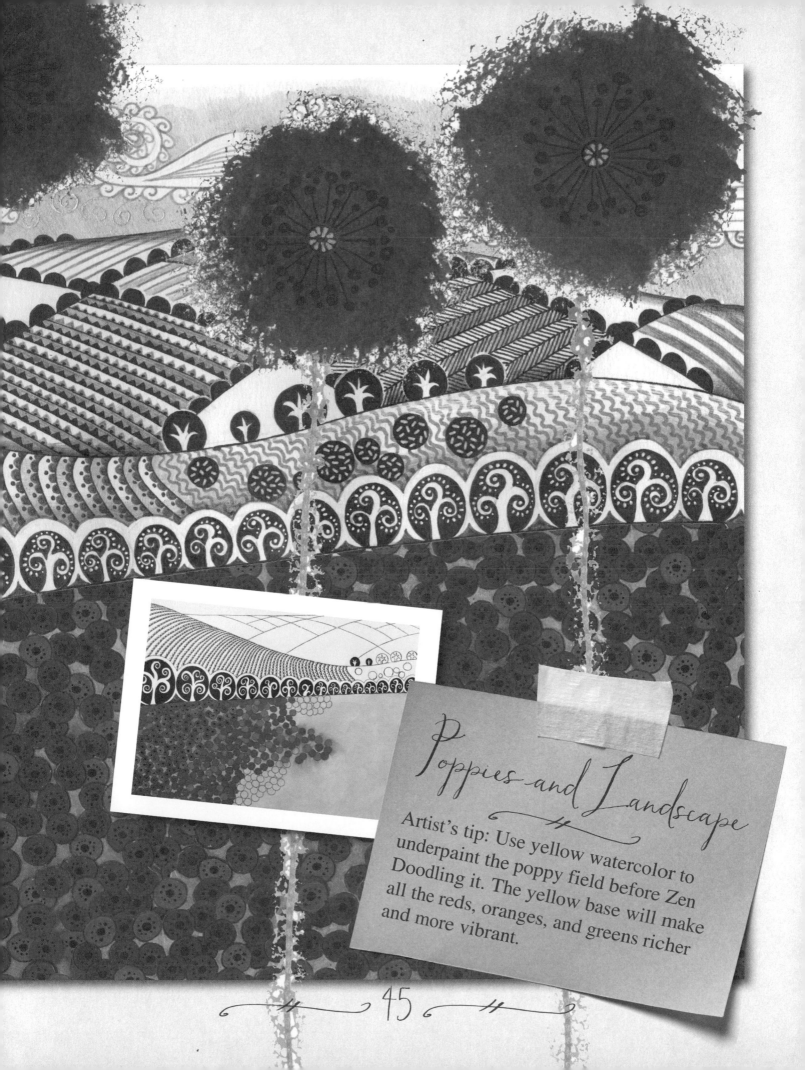

Poppies and Landscape

Artist's tip: Use yellow watercolor to underpaint the poppy field before Zen Doodling it. The yellow base will make all the reds, oranges, and greens richer and more vibrant.

Air

Air is vital to life. It is an element that manifests itself in movement and is associated with inspiration, wisdom, and the power of the mind, spirit, and soul. Air is the element that blows in new ideas and carries artistic creativity, imagination, and dreams. Air's energy can join with the elements of fire or water and can also act as a conduit between them.

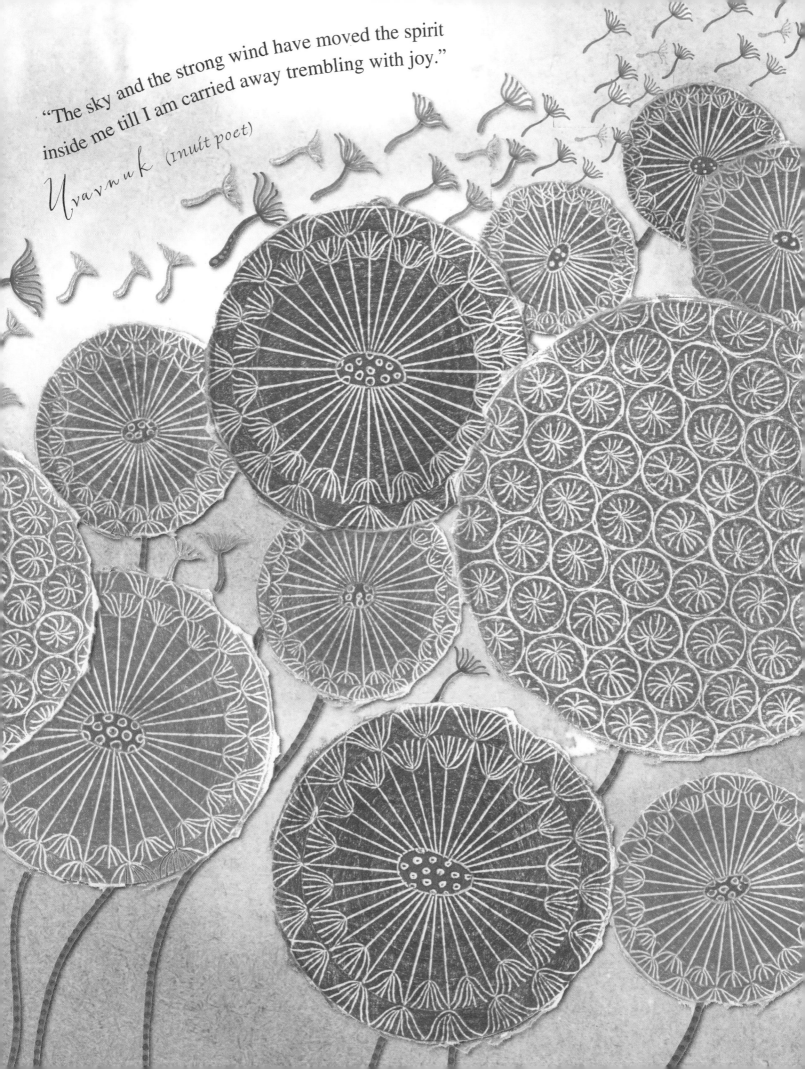

"The sky and the strong wind have moved the spirit inside me till I am carried away trembling with joy."

Uvavnuk (Inuit poet)

Air-Inspired Mood Board

Dandelion Clock

The slightest breeze will carry the dandelion clock's delicate seeds far and wide, ensuring a future generation of flowers. Folklore suggests that dandelions have extraordinary powers, including the ability to determine the strength of love. The number of breaths it takes to blow all the seeds from a dandelion "clock" is meant to reflect the hour of the day, and many believe dandelion seeds are capable of transferring thoughts and dreams to another person.

Different Techniques

I experimented using different techniques and Zen Doodles.

I used torn circles of colored paper for the dandelion heads, and double-sided tape to hold them in place. I doodled with black fineliner pens, then highlighted areas with white and silver gel pens.

Torn paper

Line and Wash

I drew circles for dandelion heads using water-soluble fineliner pen. Then, with a clean brush, I painted water inside the circles. The colored line then bled to create subtle textures. While the circles were still damp, I Zen Doodled patterns inside. Once dry, I used fineliner pen to add more detailed doodles.

Interesting effects!

Indenting

I simply used an empty ballpoint pen as a stylus. I then Zen Doodled patterns, pressing hard enough to indent the paper (thick cartridge paper works best). Shading over the indents using soft colored pencils creates a tracery of white lines.

51

Color scheme

Inspired Compositions

Thumbnail Sketches

Make thumbnail sketches of different compositions. Use them to try out variations of tone, doodles, and color combinations.

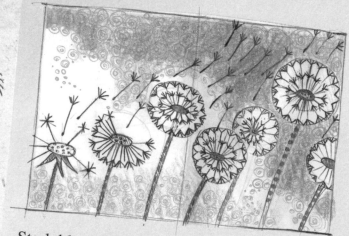

Stark black and white Zen Doodled dandelion clocks isolated against vivid blue sky with clouds...

...or a group of similar-sized dandelion clocks in black, white, and gray. Dramatic swirl of seeds flying into the distance...

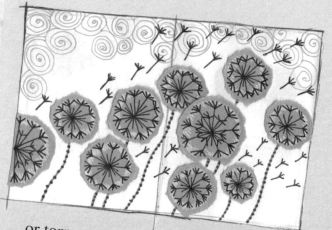

...or torn paper dandelion clocks, with black and white Zen Doodles. Pale blue doodled sky...

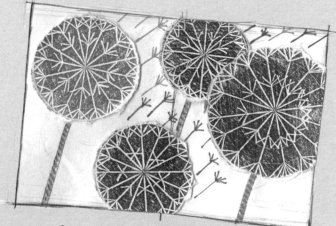

...or close-up of dandelion heads, using torn paper with indented Zen Doodles.

Dandelion Clock Doodles

I chose the final composition and decided to combine the techniques of indenting and torn paper. Now to design bold Zen Doodles to indent!

Simplified structure of a dandelion clock

Indenting

Doodling the Clock...

(1) Using compasses, draw a circle. Add a small circle at the center.

(2) Draw guidelines on either side of the small circle. Complete a row of circles.

(3) Draw in a second row, slightly offset from the first.

(4) Continue adding offset rows of circles.

(5) Lightly trace the circle patterns onto cartridge paper. Use an empty ballpoint pen to indent the design. Add shading using a dark blue colored pencil.

Blowing with the Wind

Deconstruct the Pattern

Deconstructing a complex pattern into easy steps makes Zen Doodling the finished design more relaxing and fun.

(1) Use compasses to draw a circle, then add two circular borders. Draw an oval shape in the center.

(2) Use a protractor to measure increments of 10°. Draw in lines as shown.

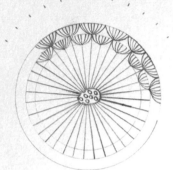

(3) Add Zen Doodle patterns (inspired by dandelion seeds) around both borders.

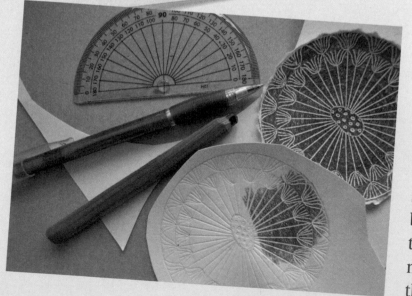

Paper Tearing

Torn paper edges are softer and more organic than those cut with scissors. Artist's tip: to make torn paper shapes, first indent the required shapes onto paper with a dry ballpoint pen. Gently tear out the shape. The torn edge will naturally follow the path of the indented line.

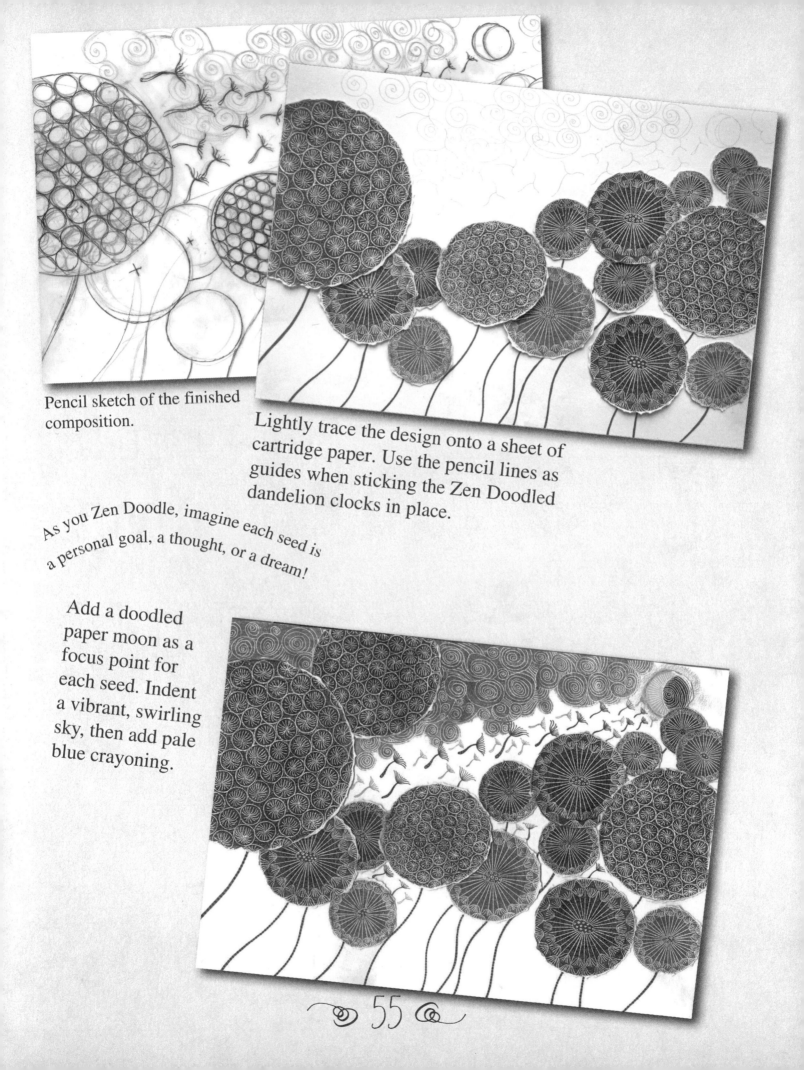

Pencil sketch of the finished
composition.

Lightly trace the design onto a sheet of
cartridge paper. Use the pencil lines as
guides when sticking the Zen Doodled
dandelion clocks in place.

As you Zen Doodle, imagine each seed is
a personal goal, a thought, or a dream!

Add a doodled
paper moon as a
focus point for
each seed. Indent
a vibrant, swirling
sky, then add pale
blue crayoning.

In the Frame

Most pictures benefit from the addition of a frame. Frames define the edges of a piece of art, supplying gravitas and giving it strength and power. A frame can also play a vital role in the overall design of a piece of artwork.

Contrast

This black frame provides tonal contrast, adding impact to the design. The frame is made from torn paper and continues the Zen Doodled theme of dandelions. I worked in gold, silver, and white gel pens.

Artist's tip: The colors of the frame should complement colors in the picture.

Note: I have found Zen Doodling this design to be a powerful aid to achieving mindfulness.

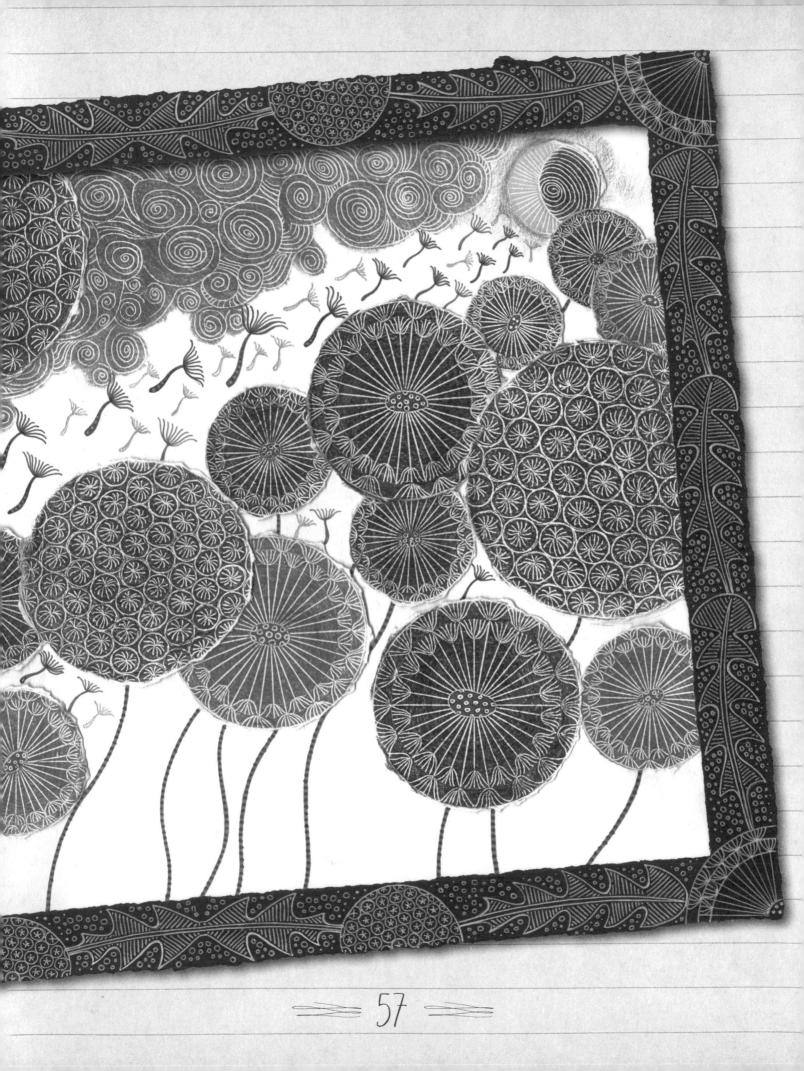

A Sea of Corn

Wind blowing over a field of corn
or grass produces a magical, rolling,
wave-like effect, akin to the sea.
Use this beautiful transformation
as further inspiration for creating
Zen Doodle patterns based on
nature.

Try to capture the sense
of movement using
flowing, curved lines.

Field of windblown corn

Ears of corn make
a checkered pattern!

Creative Doodling

When Zen Doodling is inspired by something special, I like to call it creative doodling. These patterns are my attempt at capturing the movement and shapes within a cornfield.

Composition on a Theme

Abstract pattern...

...blowing in the wind

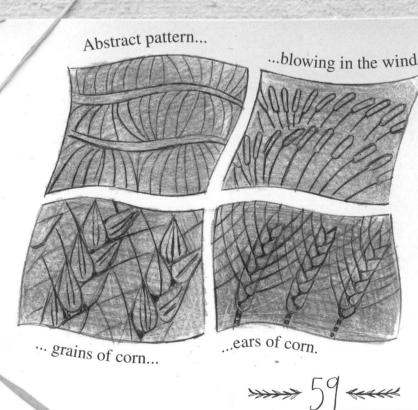

... grains of corn...

...ears of corn.

The shape of this composition reflects a theme of waves. It is split into four sections, each inspired by a different aspect of a cornfield. Each section will be printed separately.

Polystyrene Prints

This simple technique produces amazing results. A polystyrene printing block is indented with a blunt instrument. It is then inked and pressed onto a sheet of paper to produce a reverse image of the indented pattern.

Materials

Polystyrene sheet (available from craft shops, or reuse packaging)

Water-based block-printing colors (inks)

Brayer roller

A flat surface (paper plate or old baking tray) for inking the roller

Paper to print on

Cut the polystyrene printing block to the required shape. Lightly draw out the design, then use a dry ballpoint pen to indent the lines.

Inking the Surface

Use a brayer roller to apply ink to the printing block. Place the block face down onto a sheet of paper and press firmly.

Artist's tip: Try out Zen Doodle designs on a spare print. Experiment with different types of pen to see which works best on the printed surface.

Always make sure the printing ink is thoroughly dry before Zen Doodling. I used black and metallic gel pens together with fine felt-tip pens to doodle these patterns.

Light source

3D Effect

To achieve this 3D effect, first choose a light source. I used black felt-tip pen to outline the darkest edges of the design. Don't color the edges nearest to the light, but rather use a mid-tone blue to outline the remainder.

Mounting the Prints

Cut out the Zen Doodled prints and place them on a sheet of cardstock. Use a variety of black paper strips to experiment with the look of the frame. Try varying the amount of white space around the four images. Once the proportion of frame size to white space to printed images looks right, use double-sided tape to stick the four prints and the frame onto the cardstock.

Proportions

These thumbnail sketches show how differing ratios of white space to frame size can significantly affect the impact of the image.

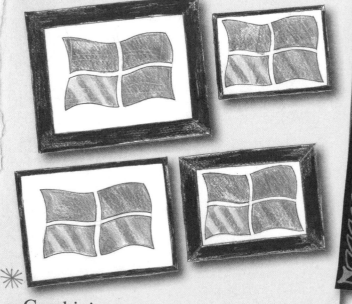

Combining a thin, dark frame with an expansive border works best.

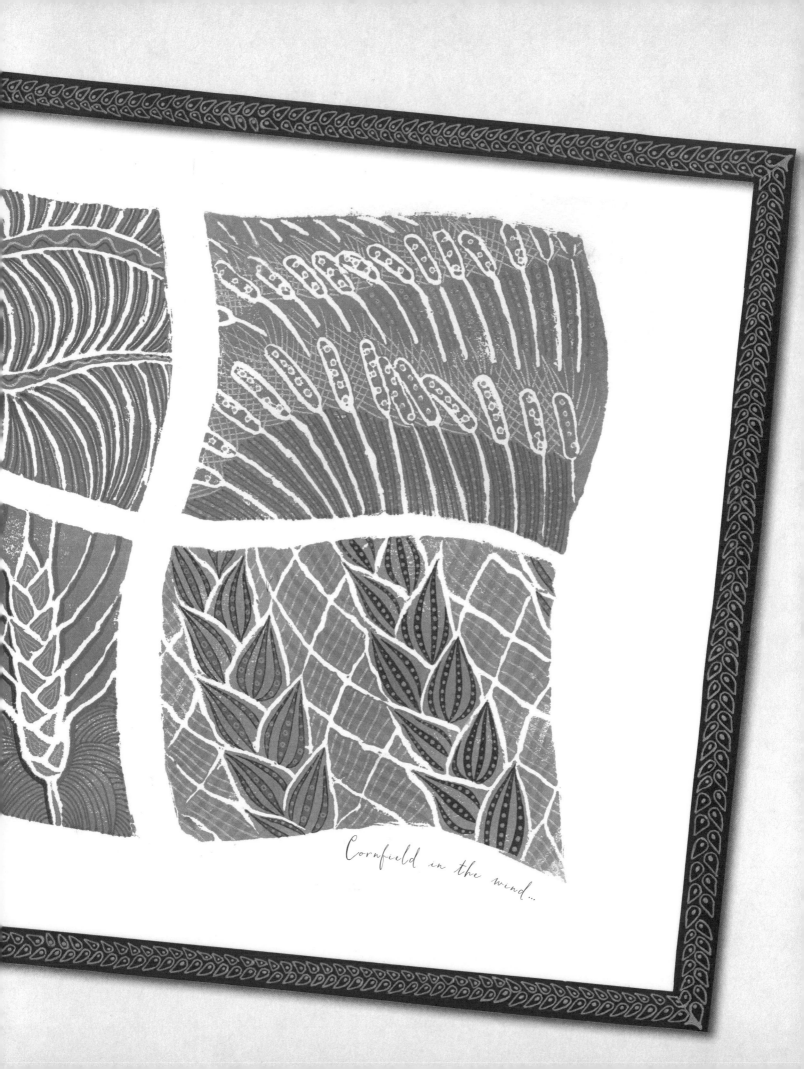

Cornfield in the wind...

Autumn Leaves

Autumn is a season of transition, reminding us of the impermanence of life. The autumn equinox marks the point in the year when day and night are of equal length—a time to accept and embrace both our inner darkness and light in order to achieve harmony and balance.

Letting Go

As trees let go of their leaves we, too, can mentally release and let go of our troubles. Walking through a park in autumn, surrounded by gloriously colored trees, is profoundly moving and inspiring. Take time to relax and live totally in the now...

Leaf Prints

Print leaves in the colors of autumn: rich golden yellows, chestnut browns, sage greens, and damson reds. Fill your mind with images of airborne leaves as you Zen Doodle the leaf prints.

Materials

A variety of different-shaped leaves (fairly fresh or they will crumble).

Water-based block-printing colors.

Paintbrush or brayer roller

Method

Use a paintbrush or brayer roller to cover the surface of each leaf with color. Turn the leaf color-side down on the paper and press it firmly with the palm of your hand.

A Windy Day

Starting a piece of artwork on a blank sheet of paper is always daunting. In this instance, I wanted to design a composition that really captured the beauty of autumn. I wanted to incorporate the fabulous colors, the wind-blown trees, and the leaves dancing in the air as they fall gently to the ground.

Different Compositions

The first step in creating any artistic composition is to roughly draw out different designs.

Accentuate the curve of the tree trunk to emphasize the effect of the wind buffeting it. Try putting different-shaped leaves on individual branches. Use bold black and gold Zen Doodles for the bark.

I think this first composition looks weak and confused. Let's look at ways to make the design stronger…

Leaf-Shaped Design

In this composition I've shaped the tree like a leaf. The tree and all its leaves are pointing in the direction of the wind.

Try using a limited palette of greens, browns, and golds.

Bold, Graphic Design

67

My use of a strong, simple pattern of tree trunks adds contrast to the dramatic color and movement of the leaves.

Materials

Oiled stencil paper (available from craft shops) or an old plastic wallet

⁓⁓

Pointed scissors or craft knife

⁓⁓

Water-based block-printing colors

⁓⁓

Old sponge

⁓⁓

Paper to print on

Tracing of leaf shape...

Leaf Stencils

Leaf stencils are easy to make and produce beautiful prints for Zen Doodling. Use leaf prints to recreate the bold, graphic design on page 67.

Method

Draw four or five medium-sized, simple leaf shapes. Remember that the size of the leaves will affect the scale of the finished composition. Then, draw a second set of smaller leaf shapes. Trace each leaf onto a piece of stencil paper, then carefully cut out each shape.

Printing

Hold the stencil firmly with one hand. Use your other hand to lightly dip the sponge into the printing color, then dab onto the stencil. Once the shape is covered, carefully lift off the stencil.

Try printing on brown wrapping paper and colored craft papers.

Brown wrapping paper

Black ballpoint pen with red, black, and gold gel pens

Leave the prints to dry completely, then cut out and Zen Doodle. Experiment with different pens to see which ones flow better over the textured paint surface.

Bark Patterns

Trees are enormously evocative. Their roots reach deep down under the earth, while their branches soar skyward. Ancient trees are imbued with a sense of timelessness, tranquillity, and wisdom that is spiritually uplifting. I find it easier to focus inward and to feel at peace with myself when I am in the midst of majestic trees.

Unique Beauty

As a tree expands in size, its protective layer of bark becomes too tight to accommodate its growth, so it cracks and splits. Each tree species produces its own unique, beautifully patterned bark.

Zen Doodle designs inspired by bark patterns

Doodled Tree Trunks

Depending on the size of the stenciled leaves, your piece of artwork is likely to be on a fairly large scale. Using the color rough (page 67) as a visual guide to the tree's proportions, cut out strips of black paper for the tree trunks. Use bronze, gold, and white gel pens to Zen Doodle the different bark patterns.

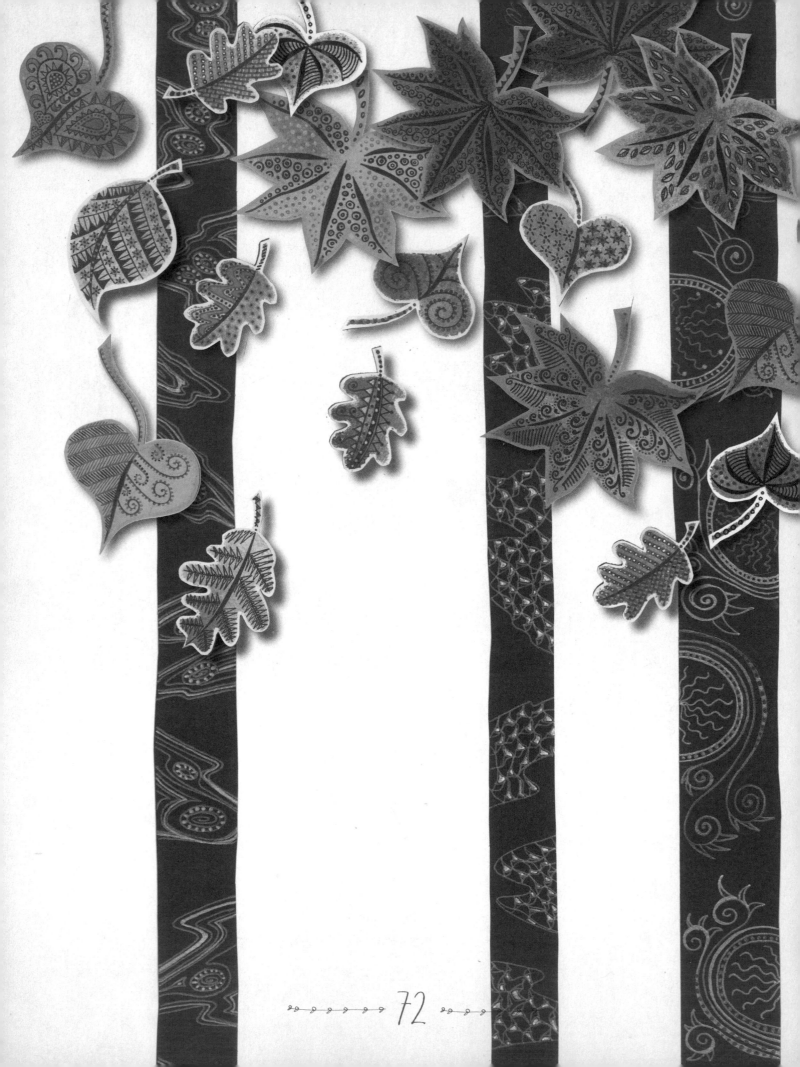

Arrangement

Using the color rough (page 67) as a positional guide, place the doodled tree trunks onto a sheet of thick, white cartridge paper or cardstock. Stick it down using double-sided tape. Before sticking on the stenciled leaves, experiment with different arrangements. Placing all the leaves at roughly the same angle adds movement and creates the effect of a breeze blowing the leaves as they fall to the ground. Choose your own composition and remember to overlap or crop leaves if desired.

Fire

Fire is symbolically linked with the sun. It lights up the sky, burns passionately in our hearts, and rages deep within the earth. While air and water are able to flow in different directions, fire can only move upward. Earth, air, and water may remain at rest, whereas fire is constantly on the move. Fire is strongly associated with the process of change: it has the power to consume, transform, and purify.

"There may be a great fire in our soul, yet no one ever comes to warm himself at it, and the passersby see only a wisp of smoke."

Vincent van Gogh

Fire-Inspired Mood Board

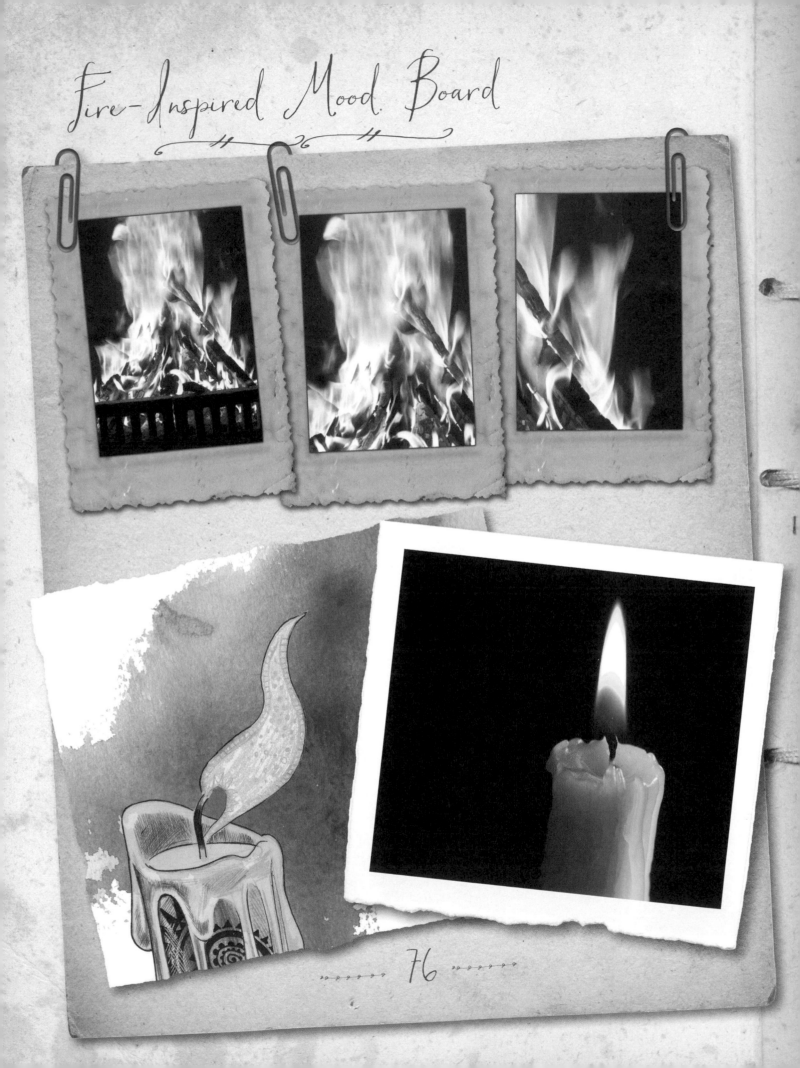

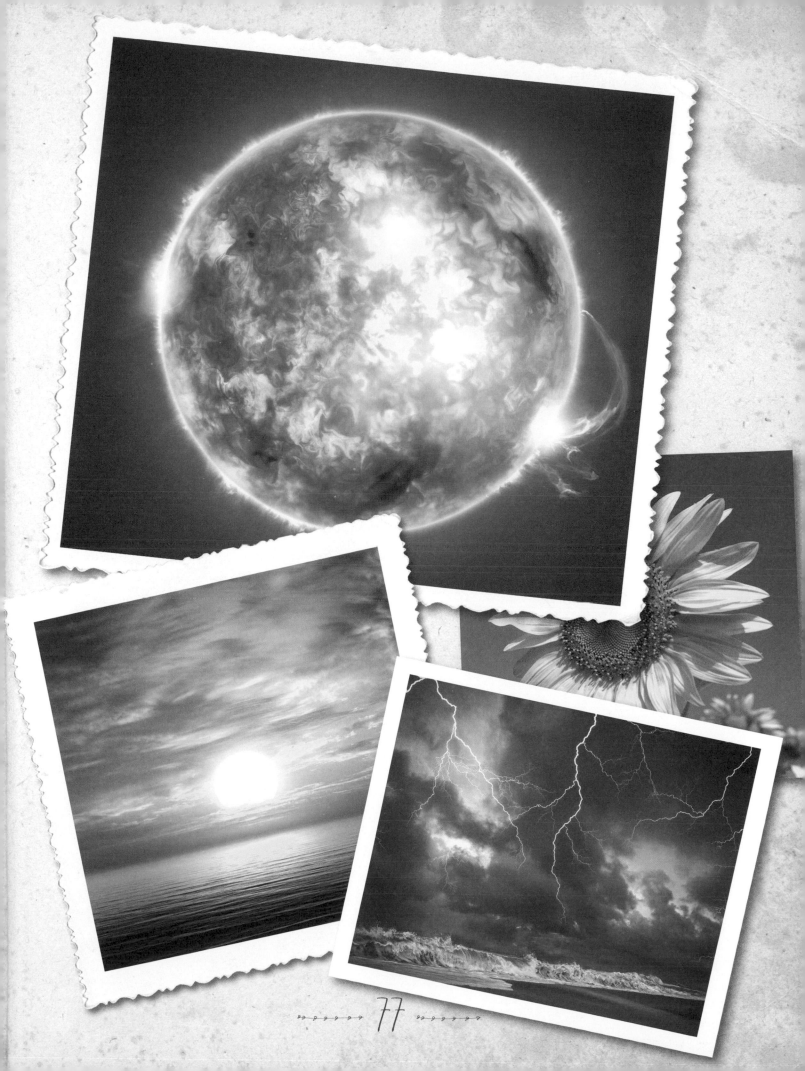

The Sun

Like a beautiful ball of fire in the sky, the sun provides warmth and energy—it gives us life. A potent symbol, it has many meanings, including those of self, life, strength, power, energy, and force.

Sunflower

The sunflower seems to me to represent the sun in flower form. Its flowerhead even follows the sun's movement across the sky in a process called heliotropism!

Oil painting

Sketch

This rough sketch of a sunflower is based on my oil painting. I've replaced the flower's head with a human face.

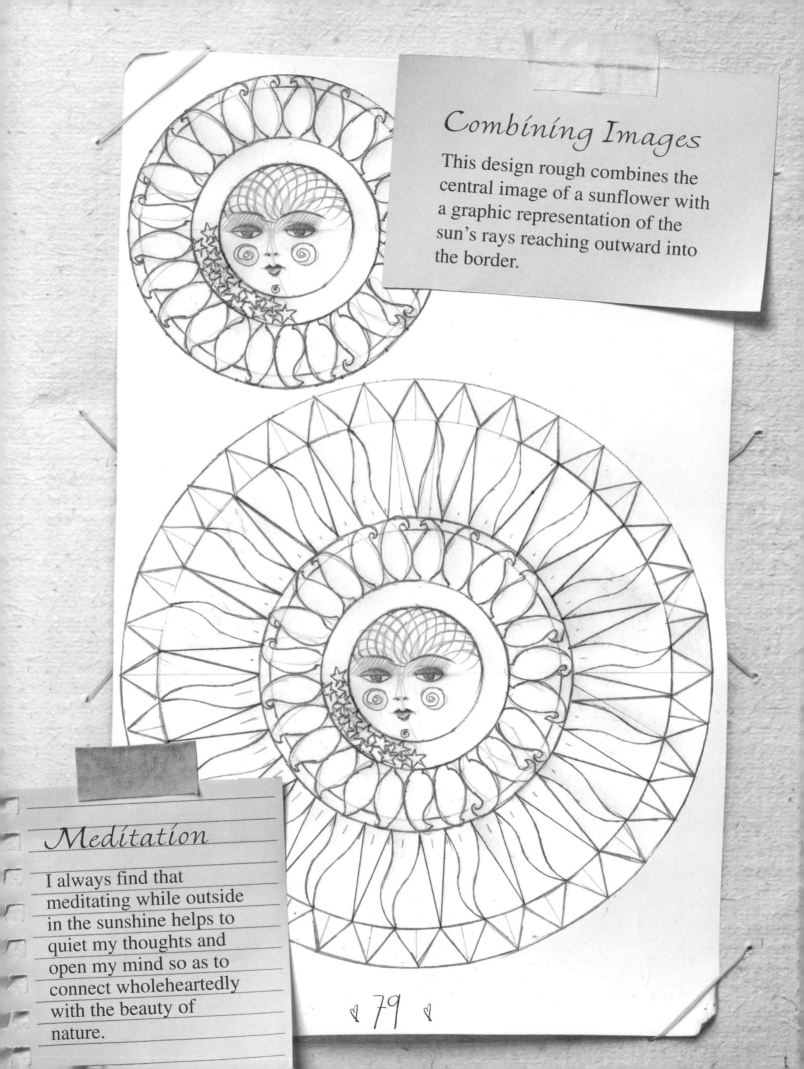

This design rough combines the central image of a sunflower with a graphic representation of the sun's rays reaching outward into the border.

Meditation

I always find that meditating while outside in the sunshine helps to quiet my thoughts and open my mind so as to connect wholeheartedly with the beauty of nature.

Using a Protractor

It's always more rewarding to be able to draw everything freehand. However, sometimes it's necessary to adopt a more technical approach if you need to achieve more accurate effects. A protractor is a simple tool for dividing circles into any number of equal sections.

Draw a horizontal line through the center of the circle. Align the protractor so that it sits centrally on the line.

Mark out increments of 5° as shown. Align a ruler with the center point, then extend each marker outward to create guidelines for drawing the patterns.

Photocopies

It's a good idea to make photocopies or tracings of more complex design roughs. Use these to try out different color combinations and patterns before you start your final Zen Doodled creation.

Drawing Out

Draw out your final composition. Block in the main areas of color (use felt-tip pens, watercolor paints, or a combination of both).

Sunflower Pattern

Start by Zen Doodling the face. Keep the features simple. I've used a swirling pattern on the forehead based on the seed structure at the center of a sunflower.

Working Outward

Continue Zen Doodling outward. I used the colors of the sun. The blue outer border represents the sky.

As you Zen Doodle, imagine the sun's golden rays bathing the world in light. Picture it warming the land, sea, and sky. Fill your mind with joy, warmth, and happiness!

Added Contrast

A limited use of black adds contrast and depth to the image. Narrow the width of the line toward the outer circle to create a 3D effect. Zen Doodle over the deep red of the middle border using a gold gel pen. Use a flame-inspired pattern to complete the outer border.

The Sky

A simple yet stunning background will complete the composition and enhance your finished artwork. I chose a cool blue paper to offset the vibrant, warm colors of the sun motif. Add gold Zen Doodles to unite the background with your sunflower artwork.

Method

I used a sheet of colored paper larger than my completed design. I located the center, then drew a slightly smaller circle than my sun image. I used a protractor to mark out increments of 5° as a guide for me to Zen Doodle a simple pattern of sun rays.

Blue Moods

If you lie on your back and look up at a bright blue sky you will experience a sense of calmness and relaxation. This is because blue is a color that reduces stress, slows the metabolism, and brings inner peace.

Presentation

Cut out your sunflower artwork, then use double-sided tape to stick it onto the background.

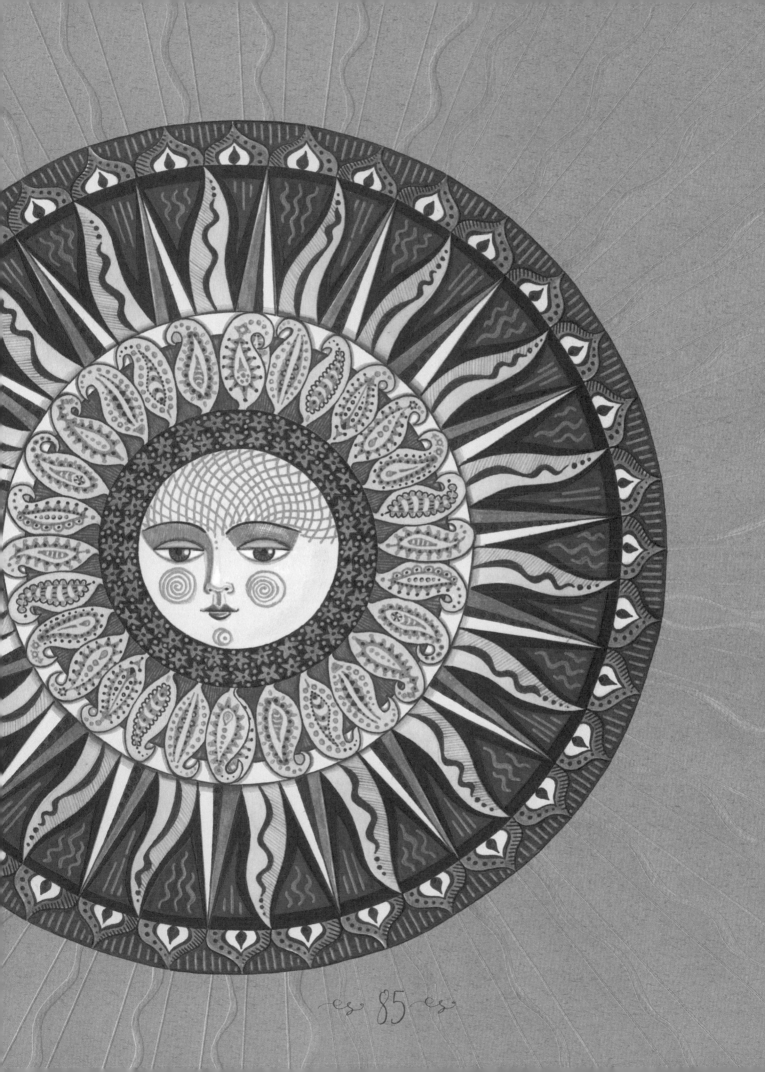

Lightning

Lightning is elemental. It is breathtaking and beautiful but frightening, too. Imagine ominous, dark clouds heralding the onset of a storm, with thunder rumbling in the distance. Picture vivid, white lightning flashes illuminating the sky, swiftly followed by the deafening crash of thunder.

Watercolor Experiment

Method

Using a damp sponge I wet a sheet of watercolor paper, blotting off excess water. With a large brush I painted a cloud shape in dark purple watercolor. You could use ink. I let the color bleed. Once completely dry, I used a white gel pen to draw in the lightning bolts. Then I Zen Doodled patterns with fineliner and gel pens.

Fluorescent colors!

Dynamic Zigzags

My aim was to suggest the dynamic movement of lightning by using geometric patterns. Lightning is usually symbolized by a zigzag shape, so I experimented by weaving several zigzags together, then added hatching to give the design a 3D quality.

Color Rough

I've used predominantly warm colors to represent the lightning, but painted a single bolt in cool contrasting colors to add impact.

Bold Abstract

Artist's tip: Use a watercolor wash to color the zigzags. First, paint each entire shape with yellow, then build up stronger colors toward the center of the design.

Zen Doodle the images using as many different zigzag patterns as possible. Color the spaces within the design using black marker pen.

As you are Zen Doodling, imagine the lightning bolt is a flash of inspiration, creativity, and enlightenment!

The Candle

Flickering candles are symbolic of love, life, and celebration. They play an intrinsic role in religious ceremonies in many cultures throughout the world.

Pencil and black ballpoint hatching adds shade and makes the candle stand out.

Realistic

This realistic sketch shows a Zen Doodled candle against a stylized background of doodled patterns. For added impact only the flame is colored.

White on Black

Take any opportunity to try out different effects and patterns, and have fun experimenting with different techniques. I used white and gold gel pens to create this stylized Zen Doodle design.

Meanings

Each part of a candle has its own meaning:

FLAME—passion

LIGHT—love, knowledge, and wisdom

WAX—purity

WICK—soul

An Illumination of Candles

Start by making thumbnail sketches of your composition.
It is worth blocking in any areas of black at this stage.
This will give you a better idea of how the finished
artwork will look.

Thumbnail Sketch

Scaling Up

Once you have chosen your
composition, enlarge your
sketch using the scaling-up
method described on page 27.
I like to draw the large image
onto tracing paper or baking
parchment first. This helps
you to see through to the
image below as you trace it.

Step One

Take a sheet of black paper the size of your finished tracing. Using a dry ballpoint pen (or hard pencil), indent the outline of the main shapes of your composition.

Step Two

You need a selection of colored papers, for example, gray, fawn, and brown. Trace the circle shapes, then use the method described on page 54 to tear out the circles. Position the circles on the black paper, then use double-sided tape to stick them in place.

Step Three

Trace out the drawings of the candles. Use black fineliner pen to Zen Doodle their outlines. Cut out the candle shapes and position them on the artwork. Use double-sided tape to stick them in place.

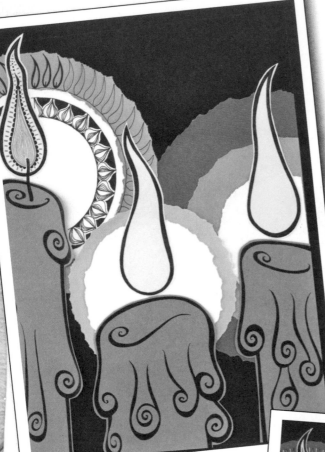

Step Four

Trace the drawings of the flames onto pale yellow paper. Draw in the outlines with black fineliner pen. Cut out the flame shapes, then position them on the main artwork. Use double-sided tape to stick them in place.

Step Five

Draw in each candle wick, then Zen Doodle the flames using gold and bronze gel pens and a black fineliner pen.

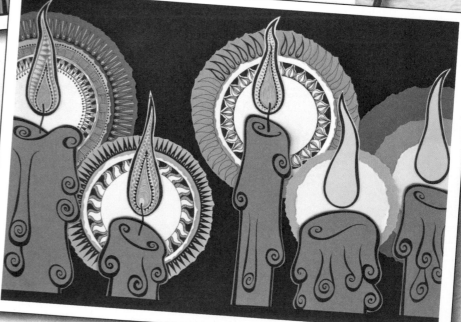

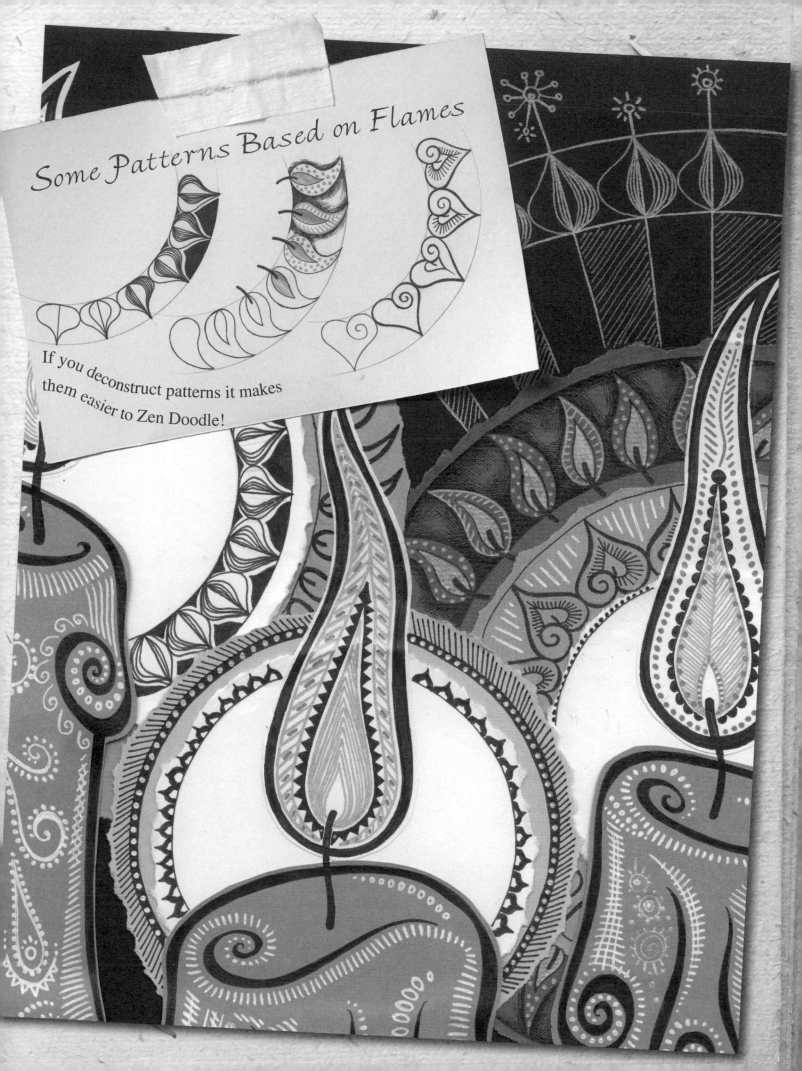

Some Patterns Based on Flames

If you deconstruct patterns it makes them easier to Zen Doodle!

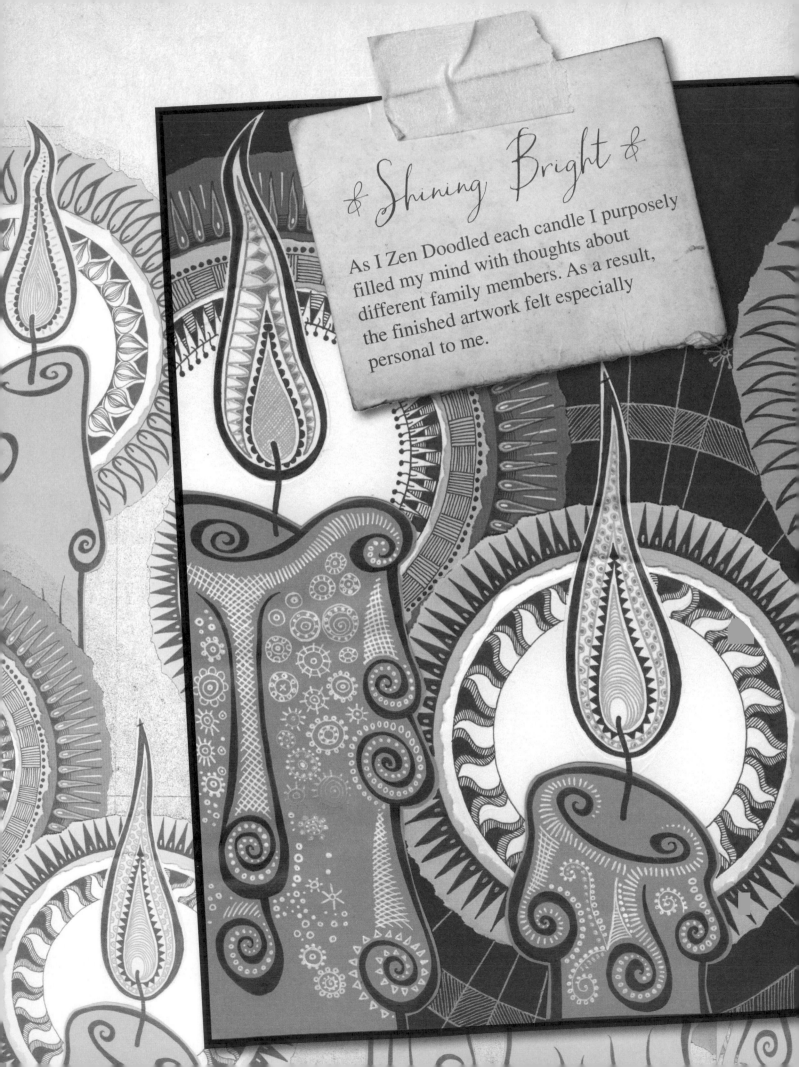

Shining Bright

As I Zen Doodled each candle I purposely filled my mind with thoughts about different family members. As a result, the finished artwork felt especially personal to me.

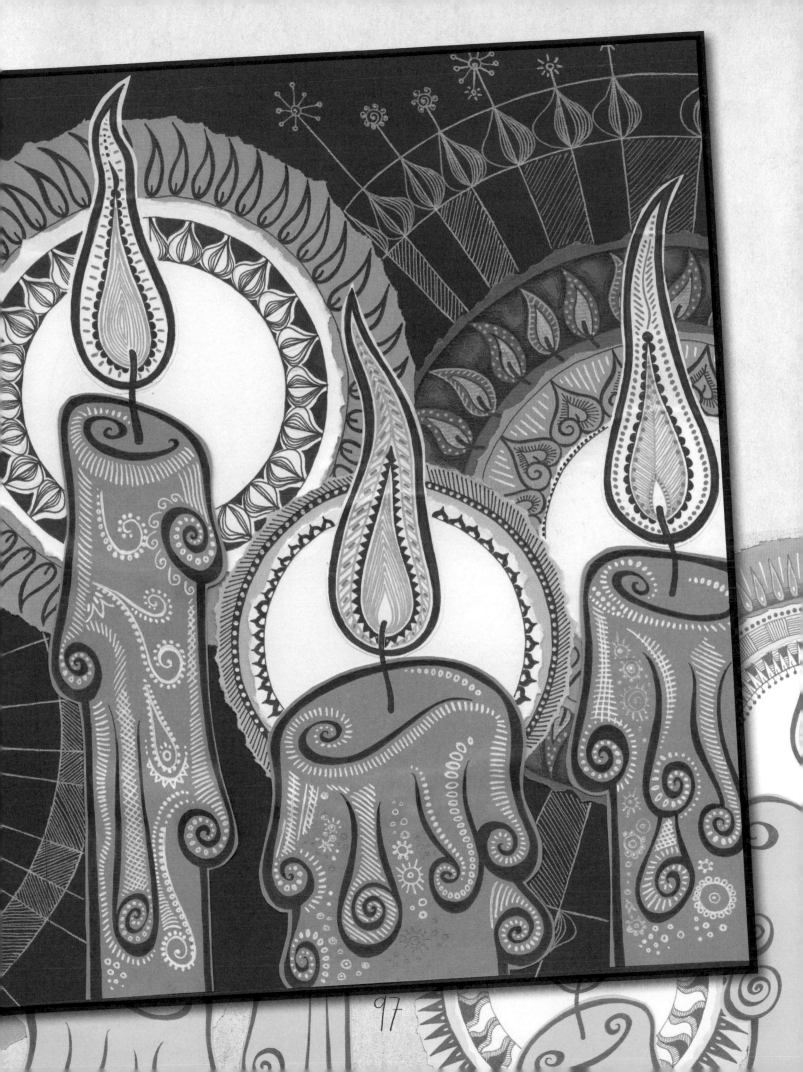

Water

Water flows with energy, bringing life and rejuvenation to the natural world. The earth, like our own body, is composed of 70 percent water. Unlike the other three elements, mercurial water has the power of transition: it can exist in liquid, vapor, or solid form. Water can be tremendously powerful, and even gently flowing water has the temerity and strength to erode solid rock. Water is steeped in meaning and symbolizes purity, change, motion, blessing, renewal, fertility, and reflection.

"A lake is the landscape's most beautiful and expressive feature... It is earth's eye; looking into which the beholder measures the depth of his own nature."

Henry David Thoreau

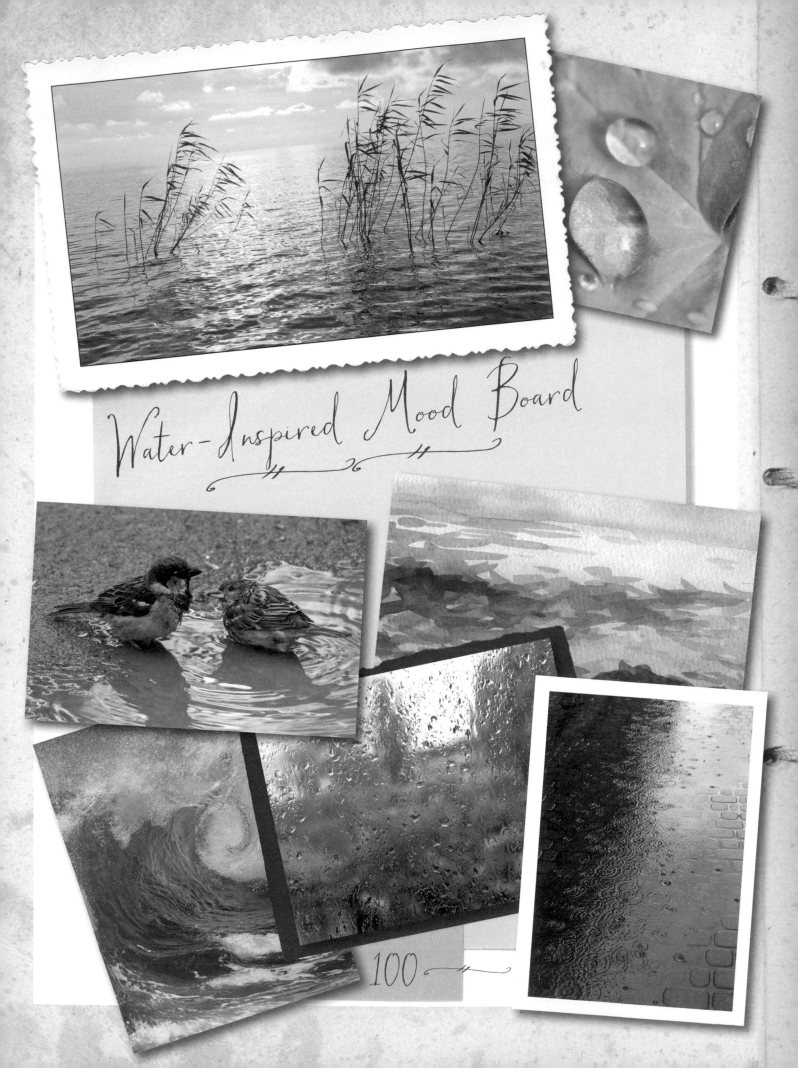

Water-Inspired Mood Board

100

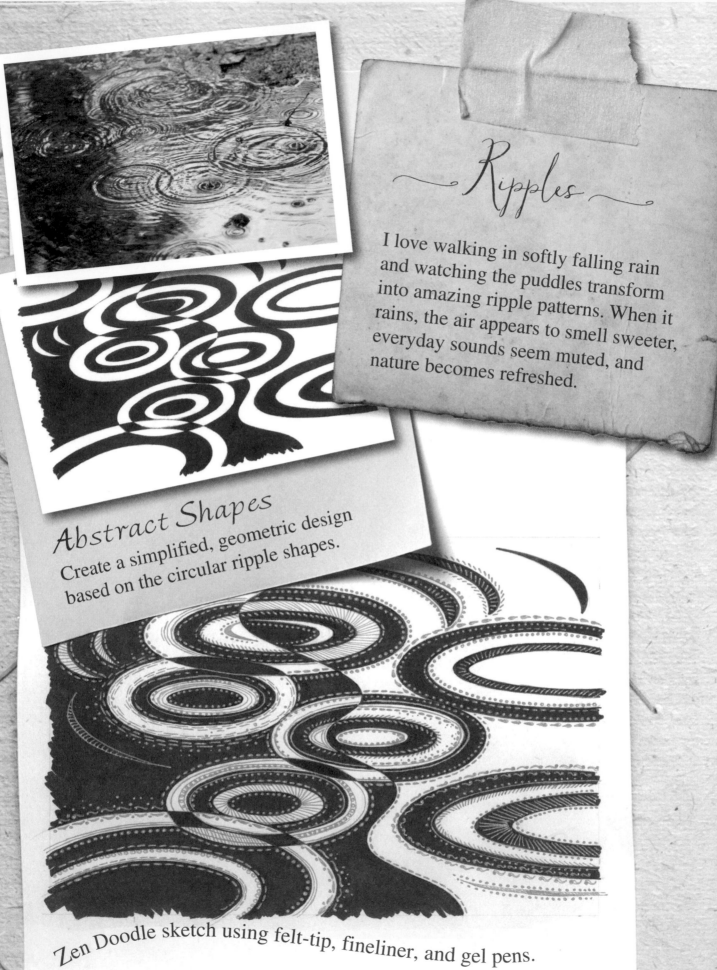

~ Ripples ~

I love walking in softly falling rain and watching the puddles transform into amazing ripple patterns. When it rains, the air appears to smell sweeter, everyday sounds seem muted, and nature becomes refreshed.

Abstract Shapes
Create a simplified, geometric design based on the circular ripple shapes.

Zen Doodle sketch using felt-tip, fineliner, and gel pens.

Movement

I wanted to capture the elusive sense of movement created by ripples in water. The ripples form stunning abstract patterns that are wonderfully inspiring for Zen Doodling.

Mixed Media

Try combining different media. I used white wax crayon to draw in the light areas, then a watercolor wash for the background. Zen Doodles were added using marker pen, white and silver gel pens, and fineliners.

Waves

The sea mirrors our human emotions—calm and tranquil one moment, then rough and turbulent the next. The sea's beauty is immeasurable, but its ferocity can be terrifying and deadly.

Design rough

Rough Sketch

Sketch out a design using sinuous, swirling lines to try to capture the ceaseless movement of the sea. Then draw out the full-size design onto watercolor paper.

Using a Resist

Using a resist will preserve white areas or lines. For this piece of artwork I painted clear masking fluid over the pencil lines and left it to dry.

Watercolor Wash

Then I painted a bold watercolor wash over the entire design. When completely dry, I rubbed off the masking fluid with a clean fingertip.

104

Pattern-free

Use blue and black fineliner pens as well as a silver gel pen to Zen Doodle over the colored areas. Try leaving parts of the design pattern-free.

Reflections

Still water was man's first physical mirror. In myths and legends it has been seen as a mirror into the soul. Like many other people, I find the tranquillity of a lake has a soothing, hypnotic quality that leads me to reflect on life. This helped me to still my mind and feel calm and serene as I Zen Doodled this artwork.

Rough composition

Composition

The mirrored image of the heron makes a perfect focal point for this composition. I have simplified the shape of the reeds, then used them to create a decorative background.

Materials

Water-based block-printing colors

～～～～～～～～

Large, smooth, flat surface for spreading the printing color (I used an old baking sheet)

～～～～～～～～

Flat dish for loading roller

～～～～～～～～

Brayer roller

～～～～～～～～

Cotton buds to draw with

～～～～～～～～

Paper to print on

Monoprinting

I decided to use monoprinting to create the background for this design. It is a wonderfully spontaneous technique. You simply apply paint to a smooth, non-porous surface and then draw on it. This removes some of the paint, leaving lines that print as white. To create the "reflection," use the wet print to make a second, ghosted mirror image.

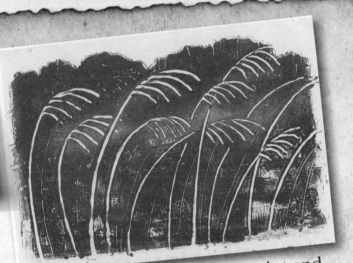

Lay paper on top of the wet paint and press down gently with your hand. Peel the paper off. The printed image will be in reverse.

Method

Paper template

First, cut out a paper template for the shape of the trees. Load the roller with color to cover the tray with paint. Lay the template in place as shown and draw your design into the wet paint.

Lay a new sheet of paper on top of the wet print, press gently with your hand, and peel off the ghost print.

Tranquil Reflections

I simplified the shape of the heron by concentrating on the graceful lines of its neck and body. I then Zen Doodled the feather patterns using pale gray fineliner and silver gel pens. Adding pencil shading to the wing feathers and under the body created a 3D quality.

Element of Surprise

Add an element of surprise to the image by using a similar color palette but different patterns on the second bird.

Stand Out

Once finished, cut around the shape of each bird, leaving a border of white paper. This will make the herons stand out from the background.

Background

Draw a line with a felt-tip pen down one side of each reed stem to give them prominence. Use silver and gold gel pens as well as felt-tip pens to Zen Doodle the patterns. Keep the background reflection pale.

Use double-sided tape to stick the birds in place.

Rainbow

A rainbow is an extraordinarily powerful symbol of hope that carries the promise of new beginnings. It represents a spiritual journey leading to the end of the rainbow, where lies one's heart's desire—a land of dreams.

Stylized color sketch of a rainbow based on this photograph.

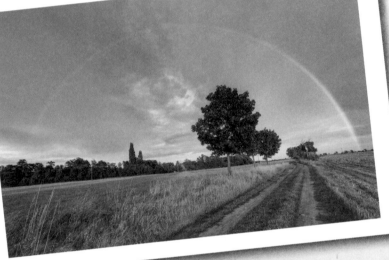

Dynamic Angle

This roughly sketched composition places the rainbow at a dynamic angle that leads from right to left. The river snaking across the picture reinforces the focal point—the setting sun.

Focal point

Trace (or photocopy) the finished design to use as a color rough for the rainbow, sun, and sky. Experiment: try using black, white, and gray in the foreground, limiting color to the swirling river, sky, and rainbow.

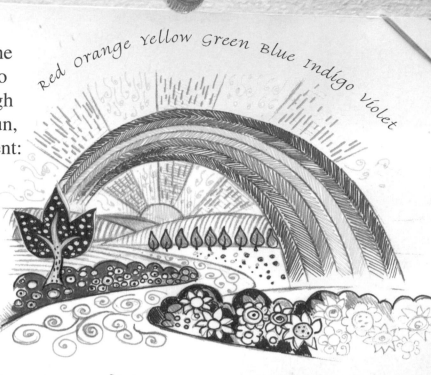

Red Orange Yellow Green Blue Indigo Violet

Raindrop Pattern Ideas

Use a simple raindrop shape as the basis for Zen Doodle patterns:

Try spacing the raindrops at random angles on a plain background. Add spiral details within the drops.

Using an angled grid, draw staggered rows of raindrops. Add a pattern of concentric rings to each drop.

Create a zigzag row of raindrop shapes. Draw in a circle with a tail, then more lines as shown.

Draw a row of large raindrops. Add a border. Fill the inside shape with smaller raindrops.

Draw up your final design, then use watercolors to paint the rainbow (or use felt-tip pens to color).

Note: I used size 0.1 – 0.8 black fineliner pens for floral doodles.

Tonal Contrast

In order to get tonal contrast in my design, I started by doodling the darkest part first—the area of fantasy flowers in the foreground. It's very relaxing doodling these bold black and white patterns.

Adapt the raindrop pattern ideas to fit the rainbow shape. Choose fineliner pens of a darker tone than the background. Gold gel pen doodling works well on top of yellow.

Adding a gray background to the small, black and white doodled flowers on the left-hand side gives the composition a sense of depth.

My idea was to shape each tree like a different leaf. I also Zen Doodled leaf shapes into the foliage of the foreground tree (left).

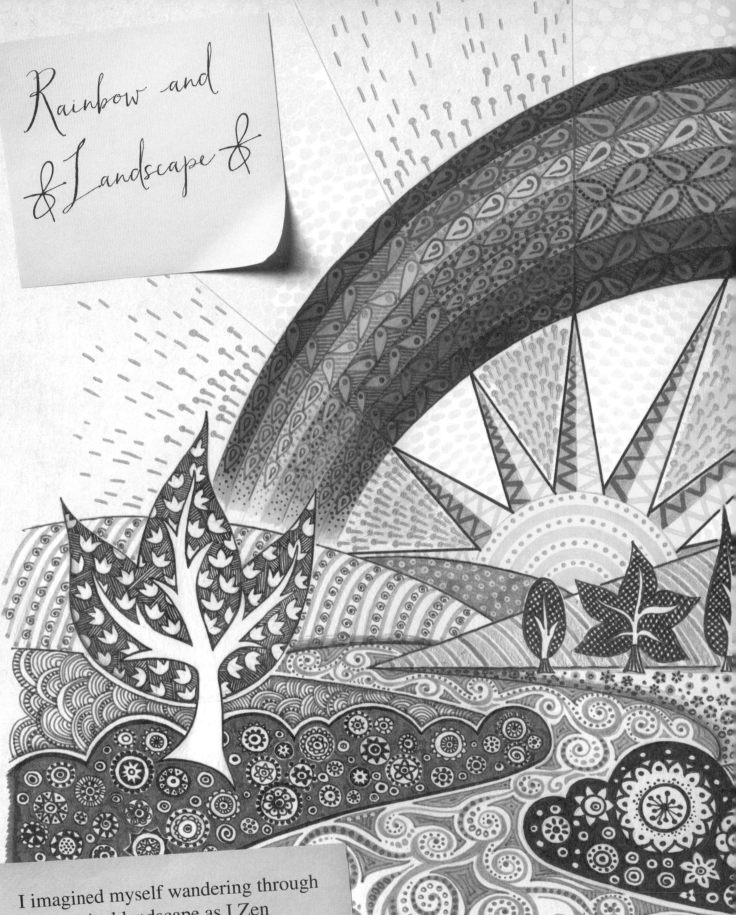

Rainbow and
✤ Landscape ✤

I imagined myself wandering through this magical landscape as I Zen Doodled. The swirling pattern of looping spirals represents the river meandering toward the sun.

Keep the Zen Doodled sky pale, so the rainbow stands out. Note: fluorescent yellow marker pens produce fantastic wedge-shaped spots—ideal for filling in large areas like the sun's rays. Try alternating this with gold gel pen doodles on top of yellow fineliner crosshatching to complete the sky.

Frost Crystals

Frost or ice crystals form when water vapor in the air freezes. Frost can make amazingly intricate patterns on window panes, leaves, blades of grass, or any solid surface.

Inspired

A Zen Doodle design inspired by frost patterns on a window pane. I used silver gel pen on dark blue paper for the best effect.

Snowflake Crystals

Snowflakes are clumps of feathery ice crystals that form in clouds when it is cold. These six-pointed, symmetrical shapes create beautiful, delicate patterns. A single snowflake can be created from up to 200 separate ice crystals. Incredibly, the shape of each flake is totally unique.

Sketch of a snowflake crystal

Paper Snowflakes

Folding and cutting six-pointed paper snowflakes is great fun and very easy to do. The paper snowflakes can be Zen Doodled upon. They can also be used as templates to trace around or for masking out snowflake shapes while printing.

Fold a circle of white paper in half. Mark the center of the circle (c).

Place a protractor on the base and line its center up with (c). Measure out 60° and 120° then fold as shown.

Fold along line bc.

Fold along line dc.

Fold in half one more time.

Snowflake Design

Draw a snowflake design on the folded paper. Cut out using sharp scissors.

Anticipation

It's great fun creating different snowflake patterns. I always feel a sense of anticipation and excitement as I open a fresh paper snowflake. Try Zen Doodling simple patterns on them, using pale shades with a few small, darker details.

3D Star Snowflakes

3D stars make fabulous shapes to Zen Doodle. Embellish them with snowflake-inspired patterns, then use as seasonal decorations.

Equipment

Ruler

Compasses

Protractor

Scissors

Blunt knife

Watercolor paper or thin cardstock

Method

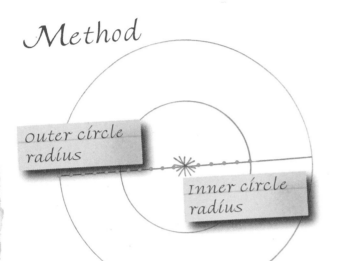

outer circle radius

inner circle radius

(1) Draw two concentric circles (outer circle twice the radius of inner circle). Add a horizontal line as shown.

(2) Mark out increments of 30°. Draw lines outward from the center to each mark.

Inward fold

Outward fold

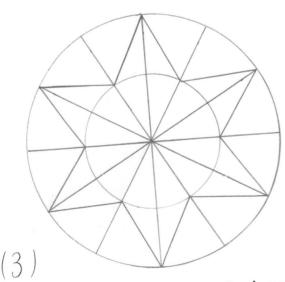

(3) Draw angled lines between the inner and outer circles as shown.

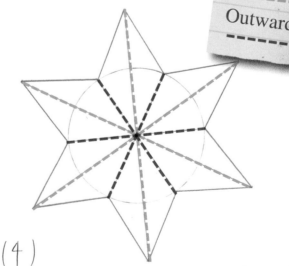

(4) Cut out the star shape. Make alternate folds, the long lines upward and the short lines downward.

Scoring Paper

Artist's tip: To make a sharp, crisp fold in thin cardstock or watercolor paper, it is best to score the line first. Lay a ruler on the paper along the fold line. Run a blunt knife along the edge of the ruler, pressing hard enough to create a line in the paper. Now fold along this straight line. Repeat.

Rough Designs

Roughly draw out a star-shaped template on scrap paper. Try out different snowflake patterns. Simply draw one half of each design and trace it to duplicate the pattern.

Three snowflake designs

Ice-Cold Snow
✳ ✳ ✳ ✳ ✳ ✳

I find that fine-grained, heavyweight watercolor paper is ideal for folding, and is thick enough to hold its 3D shape.

Tracing the pattern

Trace

Draw the star shape following steps 1 to 3 on page 120. Trace your repeating pattern. Use a black fineliner pen to outline the design.

For a 3D effect, add a band of darker blue fineliner pen as shown.

Cold Colors

Choose a limited palette of cold colors (blues, blue-greens, and turquoises) for your snowflake designs. Use fine felt-tip pens for blocking in the color. Artist's tip: Don't use watercolor paint as it may make the paper buckle and distort.

Cut and Fold

Use pale blue fineliner pens and silver gel pens to Zen Doodle the snowflake. Once the design is finished, cut out the star shape then carefully fold as shown in step 4, page 120.

Negative Space

It is the space around the snowflake design that defines its shape, so most of my doodling is in the spaces behind the pattern.

♡ Falling Snow ♡

Softly falling snow has a magical quality. It transforms even the dullest landscape into a glistening, white wonderland. I pictured a beautiful snow scene while doodling this background.

Snowy Background

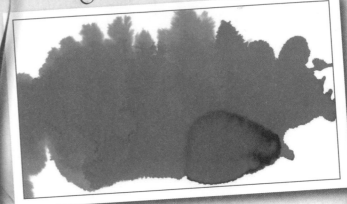

Create the background with a watercolor wash (follow the technique described on page 38). When the paint is completely dry, use a white gel pen and a pale blue fineliner pen to randomly Zen Doodle snowflake patterns.

Attach ribbons to hang the snowflake stars. Note: The stars make wonderful seasonal gifts and fabulous decorations.

Glossary

Abstract art art that uses shapes and colors in a non-realistic way

Analogous colors harmonious colors that lie next to each other on the color wheel (page 13).

Bleed the visual effect achieved when a dark color seeps into a lighter color

Color temperature the coolness or warmth of a color (blue-green is coldest and red-orange is warmest)

Compass an instrument for drawing circles and arcs

Composition the arrangement of the main parts of an image so as to form a unified whole

Cross-hatching a shading technique using two or more sets of intersecting parallel lines

Deconstruct to break down a pattern into simple components

Design a graphic representation, usually a drawing or sketch

Ghost print a faint second print made from an original print while the latter is still wet

Harmonious colors a pleasing arrangement of colors

Hatching a shading technique using a series of parallel lines

Indenting the use of a blunt instrument to indent lines on paper, which show as white after crayoning.

Light source the direction from which light shines

Limited palette a restricted number of colors used in artwork

Masking fluid a rubbery solution used to block out areas of paper so watercolors will not stick to them

Meditation the act of spending time in quiet thought

Mindfulness the focusing of one's awareness on the present while acknowledging one's feelings and sensations

Mixed media a technique using two or more artistic media

Monochrome the use of only one color or hue

Monoprint a form of printmaking where only one image can be made from the original

Mood board a display of images, colors, and textures that describe a subject

Perspective a way of portraying three dimensions on a flat, two-dimensional surface

Primary colors the three colors (red, yellow, and blue) from which all other colors can be mixed

Printmaking creating art by transferring a design by means of a printing plate, block, or stencil

Proportion how the size of one part of an image relates to the whole image

Protractor a semicircular tool designed to measure angles

Scaling up the use of a grid to enlarge a drawing to a fixed scale or proportion

Scoring lightly cutting a line on the paper surface in order to make a sharp fold

Secondary colors the colors that are made by mixing the three primary colors

Shading the lines an artist uses to represent gradations of tone

Stencil a sheet of paper or cardstock with a cutout design so that when paint is applied to it, the design will transfer to the surface beneath

Template a pattern used for making many copies of a shape

Tertiary colors the colors formed by mixing a primary and a secondary color.

Thumbnail sketch a small sketch that is quickly executed

Vanishing point a point in a perspective drawing where parallel lines appear to meet in the distance

Watercolor wash a layer of diluted watercolor painted across the paper

Wax resist a waxy medium used to block out part of the paper so watercolor will not stick to it

Index